CW00821040

Ashmolean handbooks

Miniatures

**A selection of miniatures in the
Ashmolean Museum**

Richard Walker

**Ashmolean Museum Oxford
1997**

To Margot

Published with the aid of a generous grant from
D.S.Lavender (Antiques) Ltd, London

Text and illustrations (c) the University of Oxford:
Ashmolean Museum, Oxford 1997
ISBN 1 85444 078 0 (paperback)
ISBN 1 85444 077 2 (hardback)

Titles in this series include:
Drawings by Michelangelo and Raphael
Ruskin's drawings
Camille Pissarro and his family
Oxford and the Pre-Raphaelites
Worcester porcelain
Italian maiolica
Islamic ceramics
Indian paintings from Oxford collections
Eighteenth-century French porcelain

British Library Cataloguing in Publication Data
A catalogue record for this book is available from the
British Library

Cover illustration: Samuel Cooper, *Young Man in Grey*, plate 11

Designed and typeset in Versailles by Cole design unit, Reading
Printed and bound in Singapore by Craft Print Pte Ltd

Preface

This small book skims the surface only of a remarkable collection of a particularly English art, that of the Portrait Miniature. The Ashmolean Museum collection began with those two insatiable gatherers of flowers, plants, shells, and small objects of art, John Tradescant father and son, gardeners to Charles I and Henrietta Maria, and authors of the *Musaeum Tradescantianum*. They bequeathed their treasures to Elias Ashmole, a law suit followed in which Ashmole filed a bill in Chancery against the younger Tradescant's widow, Hester, the court finally deciding in 1664 for Ashmole. This was the foundation of the Museum. During the following centuries the few miniatures in that early collection grew into a corpus covering most aspects of miniature painting, and, indeed, one of the most comprehensive in this country.

 The Ashmolean miniatures deserve a full and scholarly catalogue. Meanwhile this is an introduction only. I am profoundly grateful to David Lavender whose generosity has made it possible. I owe a great debt to Timothy Wilson who asked me to write it and has supported me throughout this most congenial task. And I thank the Ashmolean Museum staff for their help and patience, especially Jon Whiteley, Vera Magyar, Kate Eustace, Colin Harrison, and Anne Steinberg, and for photography, Michael Dudley. Preliminary work on the entire collection of Ashmolean miniatures, mainly by Gerald Taylor, has set me a high standard and I hope I have done justice to his labours in this selection. Most of his entries have been checked and annotated by Daphne Foskett, John Murdoch and the late Jim Murrell. Outside Oxford, I would like to thank,

as always, the staff of the Archive and Library
at the National Portrait Gallery, Miss K.H.Tobias
of the National Army Museum, Major David
Rankin-Hunt, the Registrar of the Royal Collection,
and Miss Susan Bennett, archivist of the Royal
Society of Arts. I hope many other helpers will for-
give me if I omit their names.

R.W.

Introduction

Miniature painting has its roots in the illuminated manuscript. Pages were often decorated with exquisite little scenes, from the Bible, mythology or literature, and were highly prized. This led to the inclusion of small portraits in the initial letters of the Gospels and breviaries (fig. 1), and then on to legal documents, city charters and deeds. In England, the tradition of miniature painting started with Henry VIII. It came to London from Bruges and Ghent, where there was a flourishing school of Flemish artists specialising in book illustrations. One of these artists, Luke Hornebolte, was the first to practise independent portraiture, and with the encouragement of the King, and indeed with his direct patronage, turned from painting initial letters on legal documents to portraits of himself, his family, and members of the Court. He described himself as the King's Limner, the word 'limning' having the same origin as 'illumination', but meaning simply 'to paint'. Hornebolte's portrait of Henry VIII (fig. 2) was one of many subsequent royal images which inspired Hamlet's line: 'my uncle is King of Denmark, and those that would make mows at him while my father lived, give twenty, forty, fifty, a hundred ducats a-piece for his picture in little'. This rather boring little miniature is the first of a succession, including some magnificent portraits of Henry VIII by Holbein and of Queen Elizabeth by Hilliard, that was to develop into a special art at which the English were to excel, with men like Nicholas Hilliard, Isaac Oliver, Samuel Cooper, John Smart, Richard Cosway, and Henry Bone (figs. 3–15). They were painted in watercolour or gouache on vellum or card, later on enamel,

For fuller accounts of
miniature painting, see
Reynolds 1952/1988,
Murdoch 1981, and
Foskett 1987.
Piper *Treasures*, p. 24,
citing the Tradescant
catalogues; cf.
Tradescant's Rarities
~vhibited 'Dynasties',
Gallery 1995, no.

and, from the beginning of the eighteenth century, on slices of ivory.[1]

The collection of miniatures in the Ashmolean Museum has its origin with the two John Tradescants, father and son, in the seventeenth century. The Tradescant catalogue of 1656 lists 'Rarities and Curiosities which my Father has sedulously collected, and my selfe with continued diligence have augmented'.[2] It continues with 'Several curious paintings in little forms, very ancient', among which was the *Man in a Green Doublet* possibly by Nicholas Hilliard (No. 2), and 'a small landskip drawn by Sir Nath: Bacon', an oil painting on copper signed with the monogram NB and possibly representing the *Flight into Egypt* (fig. 4).[3] 'The Tradescant Closet of Rarities' was assigned by Deed of Gift to Elias Ashmole in 1659, qualified by John Tradescant the Younger's will of 1661, which bequeathed the Closet 'to my dearly beloved wife Hester during her natural life, and after her decease I give and bequeath the same to the Universities of Oxford and Cambridge, to which of them she shall think fit'. Hester contested the Deed of Gift, a law suit followed which she lost, and she was found drowned in her pond in 1678. But by this time Ashmole had taken possession, Oxford had begun the construction of a handsome building in Broad Street in 1679, and in 1683 'Twelve cart-loads of Tradeskyn's rarities came

1. Master of Mary, 1475, *Margaret of York at Prayer*. Oxford, Bodleian Library
2. Lucas Hornebolte, *Henry VIII*. Cambridge, Fitzwilliam Museum
3. Nicholas Hilliard, *Self-Portrait*. London, Victoria and Albert Museum

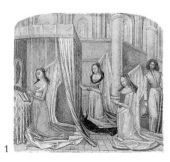
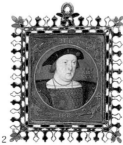

1 2 3

from Mr Ashmole in London to his new elaboratory at Oxon'.[4] The 'rarities' were of course mostly plant specimens, which were the main interest of the Tradescants, but clearly among the 'curiosities' were some *objets d'art*, and a few years later there was a burglary: among the stolen goods were a miniature of Archbishop Bancroft by Hilliard (fig. 5) and another of John Aubrey by Samuel Cooper.[5]

During the eighteenth century the fortunes of the museum declined and many of the 'rarities and curiosities' were banished to an outhouse. But a dramatic revival took place in the 1840s, with the opening of the new University Galleries in 1845, and with the gift by public subscription in the following year of part of the amazing collection of Old Master drawings formed by Sir Thomas Lawrence. This was followed in 1855 when the virtuoso, Chambers Hall, presented a large collection of works of art, including the miniature *Portrait of a Child* now attributed to Marie-Anne Fragonard (No. 72). At this time, the University possessed only a handful of miniatures, a misfortune dramatically set right by a munificent legacy from the Revd Bentinck Hawkins in 1894. Indeed, about half the present collection comes from this source. He is a shadowy figure, descended from the famous naval commander and hero of the Armada conflict. He achieved a humble degree in classics from Exeter

[4] Anthony Wood, 20 March 1683, cited in *Tradescant's Rarities*, p. 49.
[5] Correspondence between Aubrey and John Ray, cited in Reynolds 1952, p. 56. The Hilliard of Archbishop Bancroft has never been recovered but Archbishop Abbot is represented in the Museum by an engraving of William Marshall's portrait, coloured, cut to a circle, and framed in ivory to imitate a miniature. The Cooper of Aubrey has also disappeared, though Faithorne's wash and chalk drawing of 1666 is in the Ashmolean Museum (Brown, no. 123).

4. Nathaniel Bacon, *The Flight into Egypt*. Oxford, Ashmolean Museum
5. George Vertue, *Archbishop Bancroft*. Oxford, Ashmolean Museum (Hope Collection, H.P. 19,285)
6. George Vertue, *Charles Boit*. London, National Portrait Gallery

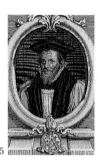
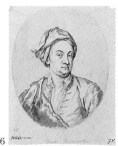

[6] Crockford's Clerical Directory and information kindly provided by the Librarian, Windsor Castle.
[7] Walker, 1992, p. xxiii.
[8] The Times, 5 September 1894, p. 3 f.; Ashmolean Museum, Annual Report, 1894, pp. 6–7; Boase, Modern English Biography, V (1912), p. 610.

College in 1824, was ordained priest in 1827, appointed chaplain to Prince Augustus Frederick, Duke of Sussex in 1831, and transferred to Adolphus, Duke of Cambridge in 1836.[6] Dolly died in 1850, with no less than thirty-five chaplains in his household, and it seems that he and Hawkins had spent a great deal of time in pursuit of miniatures. The Duke's collection passed to his son, George, 2nd Duke of Cambridge, and the first great Victorian exhibitions of miniatures, at South Kensington in 1862 and 1865, contained eleven lent by the Duke and fifteen by his chaplain. While this Duke was perhaps better known for a morganatic marriage and for his activities as commander-in-chief than for his collection of works of art, nevertheless the posthumous sale of his effects at Christie's lasted for six days, from 8 to 13 June 1904. The third day was devoted to the sale of miniatures, and snuffboxes, rings and brooches containing miniatures, many of which were bought by Queen Alexandra and the Princess of Wales, later Queen Mary, and eventually found their way back to the Royal Collection.[7] Bentinck Hawkins died at Dorchester in 1894, leaving an estate of 'upwards of £154,000', and to his brother, Dr Bisset Hawkins, his collection of miniatures and other objects, with the desire that they should be presented to the University of Oxford.[8] Dr Bisset Hawkins immediately gave the collection in his

7. H. Robinson after Henry Hysing, *Friedrich Zincke and his wife Elizabeth*. London, National Portrait Gallery
8. Gervase Spencer, *Self Portrait*. London, British Museum
9. William Bone, *Portrait of Henry Bone*. London, National Portrait Gallery

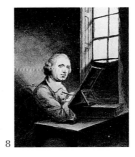

7 8 9

9

brother's name, while another huge part of the same collection, mainly clocks and Bréguet watches, was sold at Christie's in February 1895.

Hawkins's miniatures have two clear characteristics. First, their sheer quantity was staggering; very few private collections were even remotely comparable. Second, he had an eye for quality and, although he was never able to acquire any outstanding work by the great Tudor miniaturists, Holbein, Hilliard or Isaac Oliver, he compensated for the omission with a number of fine seventeenth century portraits, including *Lady Margaret Coventry* of 1655 by Hoskins (No. 8), the magnificent Samuel Cooper of *A Man in Armour* in 1667 (No. 12), and two characteristic portraits by Peter Cross (Nos. 16–17). An unusual miniature by Nicholas Dixon, of *Queen Mary II*, in watercolour on paper (No. 19), appears to be a preliminary drawing for a more important work. One of the most striking of these early miniatures is the *self-portrait of Bernard Lens*, with palette and drawing board and holding a miniature of (perhaps) his wife, Catherine, in a blue dress (No. 27).

Another characteristic of the Ashmolean collection is the number of enamel miniatures. Hawkins's bequest is rich in these choice works, and he seems to have had a special love for them. They range from three late seventeenth century works

10. Thomas Flatman, *Self-Portrait*. London, Victoria and Albert Museum
11. Richard Cosway, *Self-Portrait*. London, National Portrait Gallery
12. George Engleheart, *Self-Portrait*. London, National Portrait Gallery

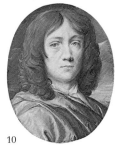 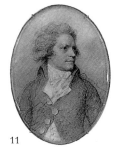 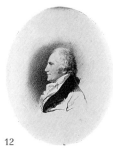

10 11 12

Williamson, *The Connoisseur* LVI, pp. 34–7. The Prince's uniform is still at Windsor Castle: see *Carlton House: The Past Glories* (exh. cat., The Queen's Gallery, London, 1991), p. 141.

by Jean Petitot (Nos. 20–22), right through into the nineteenth century with an octagonal enamel by Grimaldi of the Duke of Wellington (No. 100). The eighteenth century enamel had a special appeal for him.

While cataloguing the Bentinck Hawkins miniatures on their transfer to the University Galleries from the Ashmolean in 1897, C.F. Bell made a discovery of some interest among the enamels.[9] This was the portrait, somewhat garish in colour, of Frederick Prince of Wales, by Gaetano Manini, clearly identified by his monogram *GM* and the date *1755* on the counter-enamel (No. 34). Other choice specimens among these enamels are the prosperous-looking *Man in Blue*, and the mathematician *George Wollaston*, both by Gervase Spencer (Nos. 36, 45), the smiling *Man in Grey* by Nathaniel Hone (No. 39), two large portraits by a mysterious miniaturist, W.H.Craft, of *Sir William Hamilton* and *Sir Joshua Reynolds* (Nos. 88–9), and another of Reynolds by Charles Bestland, inscribed 'Painted in a new Permanent manner' (No. 87). Perhaps the most striking of the Hawkins enamels is the large *George IV* (No. 94), copied by Henry Bone in 1805 from Madame Vigée-Le Brun's portrait of the King, then Prince of Wales, as Colonel of the 10th Light Dragoons and wearing the flamboyant uniform designed by himself.[10] A cameo portrait

13. unknown artist after Samuel Cooper, *Portrait of Samuel Cooper*. London, National Portrait Gallery
14. John Smart, *Self-Portrait*. London, Victoria and Albert Museum
15. Isaac Oliver, *Self-Portrait*. London, National Portrait Gallery

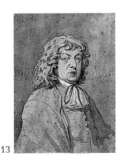
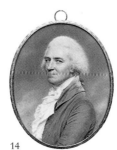
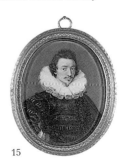

13 14 15

of the *Duke of Wellington* by Grimaldi (No. 100) ends this brief survey of a remarkable collection of enamel miniatures.

Other important additions to the Ashmolean collection came from Drury Fortnum, who died in 1899;[11] and from Francis and Winifred Haverfield, the former a descendant of Colonel John Haverfield, who married Jeremiah Meyer's daughter, Frances, in 1815. The marriage brought into the Haverfield family, later distinguished in Oxford academic circles, the probable self-portraits of Meyer and of his wife, Barbara Marsden (Nos. 40–1).[12] In 1929, Dame Jemima Church bequeathed a characteristic miniature by Gervase Spencer, painted for a member of the Church family in 1749 (No. 38), and the three Dietz miniatures of 1778, of a *Lady in White* and her daughter and granddaughter (Nos. 66–8). The De la Hey bequest of 1936[13] stemmed from another well-known Victorian collection, formed mainly by the Revd Martin De la Hey, Fellow of Keble College and Rector of Cerney, Cirencester. The bequest was of considerable importance and contained a number of striking seventeenth century miniatures, including the Hoskins portrait of *Lady Neville* with flowing hair (No. 7), a Des Granges of *Charles II* in 1650 (No. 9), an interesting Flatman believed to represent the leveller, *Sir John Wildman* (No. 15), and a *Man in Brown* of the 1690s by Nicholas Dixon (No. 18).

The last major addition was a bequest from the Revd Dr Herbert Blakiston, who died in 1942. He was President of Trinity College from 1907 to 1938, Vice-Chancellor of the University, a Visitor of the Ashmolean Museum, and a well-known Oxford eccentric.[14] The legacy included a number of miniatures of the Blunt (or Blount) family, by George Engleheart and Henry Edridge, all of very high quality (Nos. 56–63). One of them is a portrait of *Captain Charles Blunt,* who distinguished himself as a young cornet of the 15th Light Dragoons in the action at Villiers-en-Couche in 1794. A number of British officers of the regiment were awarded a

[11] Ashmolean Museum, *Annual Report,* 1899, p. 1; *Dictionary of National Biography;* Timothy Wilson, *Maiolica: Italian Renaissance ceramics in the Ashmolean Museum (Oxford,* 1989), pp. 4–7.

[12] Ashmolean Museum, *Annual Report,* 1905, p. 79, records a gift from Francis Haverfield, and that of 1920 the bequest from his widow.

[13] Ashmolean Museum, *Annual Report,* 1936, pp. 24–5.

[14] Ashmolean Museum , *Annual Report,* 1942, p. 14. H. E. D. Blakiston (1862–1942) was 'struck down by a motor car on Boars Hill' *(D. N. B.).*

[15] H.C. Wylly, *XVth The Kings Hussars 1759–1913* (1914), p. 99.

[16] Ashmolean Museum, *Annual Report*, 1947, p. 41; 1948, p. 54; 1950, p. 43; 1989, p. 27.

[17] Ashmolean Museum, *Annual Report*, 1978–9, p. 30; *National Art Collections Fund Review*, 1979, no. 2794.

special gold medal and admitted to the Austrian Order of Maria Theresa (both shown in this miniature (No. 59).[15]

Later bequests came from Miss I.G. Dumbleton in 1947, including a portrait by John Smart of her ancestor, *Sarah Buxton* – probably a wedding present when she married Charles Dumbleton in 1777 (No. 51); from Francis Mallett, also in 1947, of a magnificent Samuel Cooper, *Young Man in Armour* of about 1660 (No. 10), and a possible self-portrait of the artist, Thomas Flatman, dated 1675 (No. 14); from P.G. Heath in 1948, and Miss Helen Layton in 1953 (No. 35); and in 1989, a gift from Miss Daphne White, of a portrait by the Chevalier de Châteaubourg, perhaps of the actress Mlle Bourgoin as 'Roxelane' in 1796 (No. 73).[16]

The Ashmolean's purchasing money has never been within range of the finest miniatures, but in 1978, with generous help from many bodies, including the National Art Collections Fund and the Friends of the Ashmolean, the museum acquired a striking example of sixteenth century portraiture, the *Elderly Man in a Black Hat*, by Isaac Oliver, signed and dated 1588, and set in a sumptuous contemporary carved wood frame (No. 3).[17]

The art of limning, said one of its greatest exponents, Nicholas Hilliard, 'is a thing apart from all other painting or drawing, and tendeth not to common men's use'. Miniatures have, in the main, been treated as precious objects of delight, to be cherished, held privately in the hand, or sometimes worn as brooches or even rings. In the ruthless exposure of a museum show-case, they lose some of their mystique. But, as Dr Johnson says, 'There is nothing, Sir, too little for so little a creature as Man. It is by studying little things that we attain the great art of having as little misery and as much happiness as possible'.

Note: miniatures are painted in watercolour unless otherwise stated. Measurements are given in millimeters, height before width.

Nicholas Hilliard (1547–1619)

1 Young Man in a Lace Collar, c.1590

Hilliard, 'Limner and Goldsmith' to Queen Elizabeth and James I, was one of the finest miniaturists of all time and a leading light of the English Renaissance. Hilliard's best work is in the Royal Collection and the Victoria & Albert Museum, and the Ashmolean example scarcely does justice to his phenomenal skill. The colours have faded and there is a general air of dilapidation but, although the miniature has been disparaged in the past as 'Hilliard School', the ghost of a great portrait still remains.

Card: 33 × 22 mm, mounted in a circular turned ivory box. De la Hey Bequest, 1936 [1936.117]. Min. 188

School of Hilliard

2 Man in a Green Doublet, 1609

The miniature, which is of fine quality but sadly faded and battered, belongs to the grey area between Hilliard and Oliver, and may perhaps be by Hilliard's most skilful pupil, Rowland Lockey. It appears in a Tradescant list of 1656 among 'several curious paintings in little forms, very antient',[1] and was first attributed to Hilliard in 1911.

Vellum: oval, 40 × 34 mm, inscr. in flourishing gold letters: *Ano Dni 1609*, and mounted in a circular ivory box, the lid missing. Tradescant Collection, A 525 [1949.259]. Min. 254

Isaac Oliver (c.1565–1617)

3 Elderly Man in a Black Hat, 1588[2]

Isaac Oliver was Hilliard's star pupil and, like him, the son of a goldsmith. His style of painting, too, was more continental than Hilliard's. The difference can clearly be seen in these two miniatures: Hilliard's linear, almost abstract treatment of his sitter's face allows for very little modelling or shadow, while Oliver's striking portrait concentrates on the illusion of a third dimension.

Vellum: oval, 61 × 48 mm, inscr. in elegant gold letters: *Anno . Domini . 1.5.8.8. * AE. Suae. 71 *
Purchased (Madan Fund) with the aid of the V & A Purchase Grant Fund, the National Art Collections Fund, and the Friends of the Ashmolean, 1979 [1979.72].[3] Min. 322

[1] *Tradescant's Rarities*, pp. 291–2, no. 250, entry by Gerald Taylor.
[2] Mary Edmond suggests he may be a Dutchman (Edmond 1983). A portrait of Colonel Sonoy, also dated 1588, in the same type of black hat and similarly framed, is in the Dutch Royal Collection (Schaffers-Bodenhausen 1994, p. 374).
[3] Ashmolean Museum, *Annual Report*, 1978–79, p. 30; *National Art Collections Fund Review*, 1979, no. 2794.

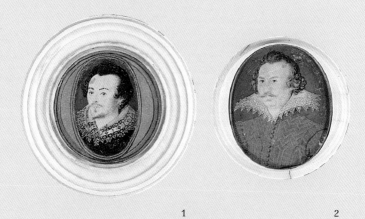

1 2

3

15

Dutch School

4 Man in a Black and White Doublet, c.1620–30

A good example of the type of continental miniature, painted in oil on brass or copper in contrast to the British miniaturists who used the lighter and more translucent technique of watercolour or gouache on card or vellum.[1] A remarkable collection of oil miniatures, similar to the Ashmolean example, is in the National Trust collection at Stourhead. Other collections are in the Uffizi, the Rijksmuseum, and the Dutch Royal Collection.

Oil on copper: oval, 53 × 42 mm, framed in a gold rim within a circular turned ivory box.
Bentinck Hawkins Collection, 1894 [1897.27]. Min. 3

Alexander Cooper (c.1605–60)

5 Man in a Scalloped Lace Collar, c.1630–35

John and Alexander Cooper were nephews of John Hoskins who taught them the art of miniature painting. John remained in England, attached to the Court, while Alexander went abroad to Holland, Denmark and Sweden, where he became Court Painter in Copenhagen and Stockholm.[2] In Holland, he was patronised by the exiled Bohemian royal family, and this portrait, which from the costume may be dated to c.1630–35, could be the likeness of a man in the circle of Frederick, Elector Palatine, and Elizabeth, the Winter Queen. Alexander Cooper often signed his work with the initials *A C*, but not in this case. A similar portrait, of an unknown man, datable to c.1640, is in the Dutch Royal Collection.[3]

Vellum on card: oval, 31 × 25 mm, unframed.
Bentinck Hawkins Collection, 1894 [1897.30]. Min. 6

Attributed to **Franciszeck Smiadecki**

6 Man in a Black Slashed Doublet, c.1665

The attribution was suggested by Mrs Foskett, who based it on a group of oil miniatures signed *FS*. It is now attributed to the Polish artist, Smiadecki.[4]

Oil on card: oval, 71 × 57 mm, framed in an oval gold locket.
Presented by Sir Arthur Evans, 1921 [1921.9]. Min. 167

[1] Foskett 1987, pp. 28–9.
[2] NPG 1974, pp. 86–8. An interesting group of his miniatures is reproduced in Murdoch 1981, pp. 120–9.
[3] Schaffers-Bodenhausen 1993, p. 379, no. 504.
[4] NPG 1974, pp. 112–3; Reynolds 1988, p. 64.

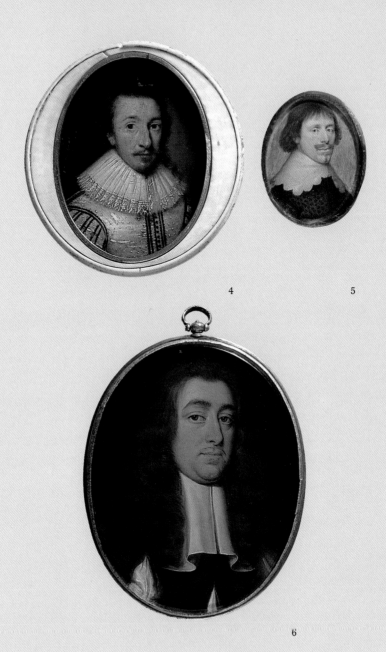

4

5

6

John Hoskins (before 1600–1645/6)

7 Lady Cecilia Neville, c.1615–20

Lady Cecilia was a daughter of Henry, Earl of Abergavenny. John Hoskins, 'Limner to His Majesty', bridged the gap between the formality of Elizabethan portraiture and the broader impressionism, influenced by Van Dyck, of Samuel Cooper. His many portraits of Charles I and Henrietta Maria[1] were complemented by those of the royalist nobility such as the Dysarts of Ham House and the Earl and Countess of Dorset, grandparents of Lady Cecilia Neville.[2] This is an early work by Hoskins, showing the sitter with the loose flowing shoulder-length hair symbolising virginity.[3]

Vellum: oval, 47 × 39 mm, signed on left in gold monogram: *JH*.
Oval ivory locket carved with a rose within a heart.
De la Hey Bequest, 1936 [1936.101]. Min. 172

John Hoskins and his son John (1615/20–after 1660)

8 Lady Margaret Coventry, 1655

Lady Margaret was a daughter of the Earl of Thanet and granddaughter of Richard, Earl of Dorset. She married George, 3rd Baron Coventry. This is a late work, painted when John Hoskins senior's eyesight was failing, and may well be by his son John.[4] Another miniature of the same sitter, by Samuel Cooper, was formerly in Lord de Clifford's collection.

Vellum: oval, 63 × 47 mm, signed and dated on the tapestry at left: *H 1655*.
Bentinck Hawkins Collection, 1894 [1897.41]. Min. 17

David des Granges (1611–1671/2)

9 Charles II, 1650

One of several Des Granges portraits of Charles II, painted in exile either in Holland or Scotland.[5] David des Granges began his career under Charles I and was appointed 'His Majesty's Limner in Scotland' in 1651. The Ashmolean miniature is clearly dated 1650, and shows the prince as a hopeful young man of twenty, somewhat in the vein of Van Dyck.[6]

Vellum: oval, 70 × 58 mm, signed and dated, lower left, in black paint: *D.G. 1650*. Oval brass locket with spiral crest.
Newdegate Collection; De la Hey Bequest 1936 [1936.114]. Min. 185

[1] Royal Collection, Dutch Royal Collection, Madresfield, etc; see Foskett 1987, pl. 17; Murdoch 1981, figs. 109–14; Reynolds 1988, fig. 21.
[2] Murdoch 1981, colour pl. 20 and figs. 108, 114.
[3] The type originated with Hilliard's splendid portrait of Queen Elizabeth as 'Stella Britanniae', c.1600, and was popularised by his bridal portrait of Lady Elizabeth Stanley of 1614.
[4] A brave attempt to face up to the Hoskins problem, father and son, is in Murdoch 1978.
[5] There are versions at Welbeck and Althorp, and variants in the Royal Collection, National Portrait Gallery, and Ham House; see Reynolds, forthcoming; NPG 1974, no. 209; and Murdoch 1981, p. 138.
[6] See RA 1960–61, pp. xi–xii, nos. 680–81.

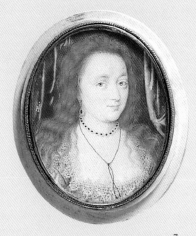

7

8

9

Samuel Cooper (c.1608–1672)

10 Man in Armour, c.1660

Cooper is among the great portrait-painters of the seventeenth century. Indeed, his unfinished miniature of Cromwell has been described as 'one of the most moving, one of the greatest of British portraits'.[1] In the exhibition of Cooper's work at the National Portrait Gallery in 1974, the Coopers from the Ashmolean clearly demonstrated his outstanding distinction as an artist. The *Man in Armour* is a distinguished and perceptive portrait of a self-confident young officer; the former attribution to Thomas Flatman was corrected to Cooper by Mrs Foskett.[2]

Vellum on card: oval, 75 × 62 mm, in a chased gold locket backed with red velvet.
Bequeathed by J. Francis Mallett, 1947 [1947.191.M.293]. Min. 252

11 Young Man in Grey, c.1660–5

This is a superb portrait of a thoughtful young man of the 1660s, wearing a grey military coat with scarlet epaulettes.[3] He was formerly identified as John Wilmot, Earl of Rochester, poet and rake, but is clearly a more sober character, quite unlike the flamboyant images of Rochester by Huysmans and Lely.[4]

Vellum: oval, 76 × 62 mm. Oval ebonised frame similar to those at Ham House.
De la Hey Bequest, 1936 [1936.103]. Min. 174

12 Man in Armour, 1667[5]

The red riband suggests that the sitter may have been one of the Knights of the Bath created by Charles II at the Restoration. Lord Dover, whose name was engraved later on the locket, was never a member of the order. Lord Arran has been put forward, without much conviction, on the grounds of a similar portrait by Cooper at Welbeck Abbey. Possible candidates are Sir Richard Temple, Bart (1634–97), Sir William Portman, M.P. (1640–90), and Sir John Scudamore, Bart (1630–84) – all Knights of the Bath created by Charles II, and of a suitable age to match this sitter.

Vellum: oval, 74 × 62 mm, signed in monogram and dated, lower left, in black paint: *SC 1667*. The gold locket engraved: *Henry Jermyn Lord Dover by Saml Cooper 1667*.
Bentinck Hawkins Collection, 1894 [1897.36]. Min. 12

[1] Piper 1992, p. 90.
[2] NPG 1974, nos 92, 120, 123.
[3] Reynolds 1952, pl. IX; Foskett 1974, pl. 53
[4] Piper 1963, p. 298.
[5] Basil Long lists six Cooper miniatures in the Ashmolean, describing the 'Man in Armour' as 'very good' (Long 1929a, p. 89).

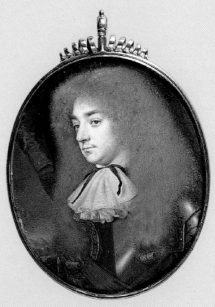

10

12

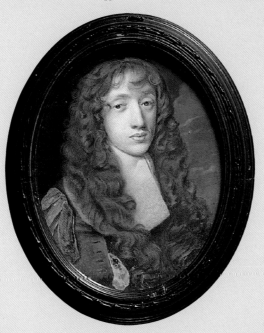

11

Richard Gibson (c.1605–90)

13 Robert Porter, c.1660

The sitter's identity as the ejected parson, Robert Porter, was established from the armorial engraving on the locket. The artist, the dwarf Richard Gibson, was employed by Charles I as a copyist, is believed to have painted Cromwell, and after the Restoration continued to work for Charles II and James II, and indeed acted as drawing master to James's daughters, Mary and Anne. His work is often recognisable from the faint parallel striations on the flesh.[1] Portraits by Lely of Gibson and his dwarf wife, Anna, are in the Kimbell Art Museum, Fort Worth.

Vellum: oval, 64 × 53 mm, mounted in a gold locket with engraved arms of portcullis over shield with two bells and five florets on a club.
Bentinck Hawkins Collection, 1894 [1897.40]. Min. 16

Thomas Flatman (1635–88)

14 Man in Brown Velvet, 1675

A fine example of Flatman's mature work, still showing the influence of Samuel Cooper but clearly marked with the unmistakeable Flatman stamp, especially in the harsh sky background, the highlights of the clothes, and the wiry modelling strokes learnt from his friend, the engraver John Faithorne. The identity of the sitter is unknown at present, but Flatman moved in a wide circle ranging from Winchester, both Oxford and Cambridge, to London where he was a member of the Inner Temple and a Fellow of the Royal Society. The Ashmolean miniature could perhaps be a self-portrait.[2]

Vellum: oval, 72 × 59 mm, signed in monogram and dated: *TF 1675*.
Bequeathed by J. Francis Mallett, 1947 [1947.191.M.292]. Min. 251

15 Portrait of a Man, called Sir John Wildman

The sitter's identity as Sir John Wildman (1621?–1693), leveller and antagonist of Cromwell, is suspect. He is unlike the portraits by Hoskins (V & A Museum) and Hollar (engraved in 1655), though the expression is certainly characteristic of this ferocious man.

Vellum: oval, 56 × 48 mm, signed in monogram, lower left, in gold: *TF*. Gilt metal locket with spiral crest.
De la Hey Bequest, 1936 [1936.107]. Min. 178

[1] It was formerly attributed to Dixon or Cooper (Williamson 1904 I, p. 75), and finally classified as Gibson in Murdoch & Murrell 1981.
[2] There are self-portraits by Flatman in the National Portrait Gallery, Victoria & Albert Museum, British Museum and Knole (Reynolds 1952, pl. XII and Reynolds 1947, pp. 63–7).

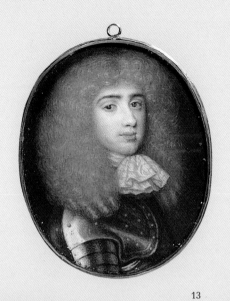

13

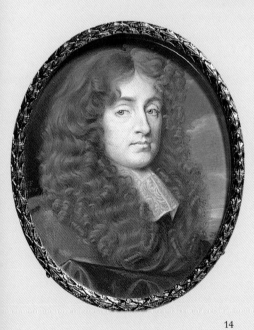

14

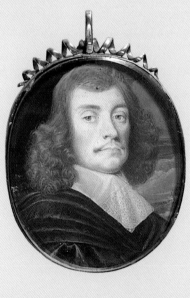

15

Peter Cross (*c*.1645–1724)

16 Mr Danvers, 1683

By 1683 Peter Cross had established himself as the lead-
ing miniaturist in London, succeeding to the practices
of Hoskins, Cooper and Dixon, with a wide circle of sit-
ters drawn from the late Stuart court and political
scene.[1]

Vellum: oval, 82 × 68 mm, signed clearly with cursive initials in
monogram: *PC*. The gunmetal locket engraved: *Mr Danvers AEtat:
30: 1683.*
Bentinck Hawkins Collection, 1894 [1897.49]. Min. 25

17 Duke of Lauderdale, *c*.1698

The portrait, signed with the initials instead of Cross's
more usual cursive monogram, formerly attributed to
Paolo Carandini or Penelope Cleyn, is now firmly
ascribed to Peter Cross.[2] The identification as Lauder-
dale is less certain.[3]

Vellum: oval, 78 × 63 mm, signed, lower right, in underlined capitals
in gold: *PC*.
Bentinck Hawkins Collection, 1894 [1897.43]. Min. 19

Nicholas Dixon (c.1645–after 1708)

18 Man in a Brown Cloak, *c*.1690

Dixon succeeded Cooper as limner to Charles II and
was appointed Keeper of the King's Picture Closet.[4] The
miniature is a good example of Dixon's unassuming
work, with scratchy lines, characteristic shadows and
'goitre-like' lower eyelids.[5]

Vellum: oval, 62 × 52 mm, signed in monogram, lower right, in
white: *ND*. Gilt metal locket with spiral crest.
De la Hey Bequest, 1936 [1936.105]. Min. 176

19 Queen Mary II, 1695

The miniature is unsigned but attributed to Dixon on
stylistic grounds. The image derives from Wissing's
portrait of the Queen, painted in Holland in 1685, of
which versions are in the Royal Collection and else-
where.[6] The unusual technique of watercolour on paper
suggests a preliminary study.

Paper: oval, 76 × 60 mm, unframed.
Bentinck Hawkins Collection, 1894 [1897.47]. Min. 23

[1] Edmond 1979, p. 585;
Murdoch 1981,
pp. 157–62; Reynolds
1988, pp. 84–6.
[2] Williamson 1904 I,
p. 37; Long 1929b,
p. 60; Murdoch 1981,
p. 159.
[3] Miniatures of Lauder-
dale include those by
Flatman in the Royal
Collection, by Cooper,
dated 1664, in the
National Portrait Gal-
lery and Earl of Jersey
collection, and by
David Loggan, dated
1678, at Antony House
(see RA 1960–61 and
NPG 1974).
[4] Murdoch 1981,
pp. 154–7.
[5] Reynolds 1988, p. 82.
[6] Piper 1963, p. 225.

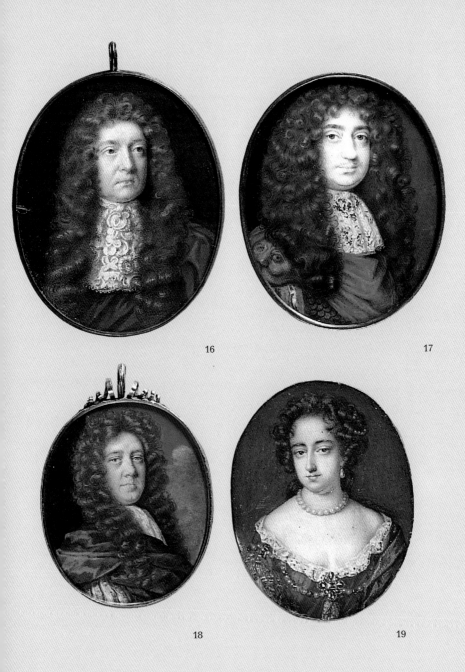

16

17

18

19

25

Jean Petitot (1607–91)

20 Louis XIV

One of innumerable Petitot miniatures of Louis XIV, but of an unusual type, formerly in the Royal Collection and presumably disposed of by William IV, after the death of his compulsive collector brother, George IV.

Enamel: oval, 53 × 44 mm. Oval gold locket engraved: *Louis XIV by Petitot from the Collection of His late Majesty George IV 1832.* Bentinck Hawkins Collection, 1894 [1897.156]. Min. 132

21 Duchesse d'Aguillon

Marie-Madeleine de Wignerol, marquise de Combalet (1604–75), was a niece of Cardinal Richelieu and created duchesse d'Aiguillon in 1638. The original miniature by Petitot is in the Louvre, with a version in the Victoria & Albert Museum.[1] The two Ashmolean miniatures of Louis XIV and the Duchess, though not of prime quality and probably studio productions, are examples of an ancient technique, probably originating in China centuries ago, that of enamel painting.[2] The process arrived in England with Jean Petitot, who was employed by Charles I, mainly to copy Old Masters. The result was a jewel-like glitter, very effective on watches, snuffboxes, rings and brooches, and was skilfully practised in England by Boit, Zincke, Meyer, and Henry Bone and his family. A large collection of Petitot enamels, including his self-portrait initialled *JP*, is at Welbeck.[3]

Enamel on gold: oval, 29 × 25 mm, unframed. Bentinck Hawkins Collection, 1894 [1897.174]. Min. 308

Attributed to **Petitot**

22 Charles II

A miniature of good quality but very much a borderline case, painted by an artist in the circle of Petitot and Boit, and deriving from a portrait by John Riley. A similar miniature is in the Wallace Collection.[4] The engraved identification with James II is mistaken.

Enamel on gold: circle 20 mm diameter, in an octagonal brass locket edged with blue enamel, engraved: *Jacques II Roi D'Angleterre – Email sur or.* Bentinck Hawkins Collection, 1894 [1897.54]. Min. 30

[1] *Les Emaux de Petitot du Musée Impérial du Louvre* (Paris, 1862), I, p. 4.
[2] P. F. Schneeberger, *Les Peintres sur émail génevois au XVII–XVIII siècles* (Geneva, 1958).
[3] Goulding 1916, p. 47, and no. 280, pl. XXIV for a self-portrait.
[4] Reynolds 1980, no. 23.

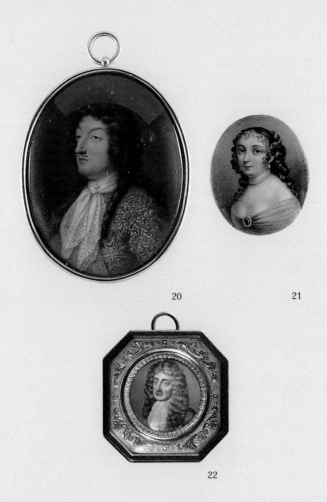

20 21

22

Charles Boit (1662–1727)

23 Helena Fermor, c.1700

Mrs Fermor was the mother of Arabella, the heroine of Pope's *Rape of the Lock*. The dealer's label attributes the miniature to Zincke but this is unconvincing and there seems to be no reason to doubt Boit's signature, clearly inscribed at the end of the spud.[1] The portrait is very much in the manner of Boit's friend and fellow Swede, Michael Dahl. The comparatively large scale of the enamel is characteristic of Boit's style, though he produced others even larger, for instance the magnificent Queen Anne and Prince George of Denmark of 1706, in the Royal Collection.[2]

Boit was born in Sweden, apprenticed as a goldsmith and jeweller, but learnt the art of enamel painting in Paris from Petitot and Bordier. He arrived in England in 1687 and established a thriving practice at Court, both copying pictures and painting *ad vivum* portraits of which Nos. 23 and 24 are typical specimens.[3]

Enamel on copper: rectangle, 117 × 90 mm, signed in front on the spud: *C. Boit pinx*, and inscribed on the backboard in ink: *Mrs Helena Fermor wife of Hon Fermor Esq of Tusmore* [Park Oxon] *and Mother of Bell Fermor, originally painted by Zincke. Price 80 Guineas R Napier.*
Bentinck Hawkins Collection, 1894 [1897.69]. Min. 45

24 Lady in Blue, c.1700–10

The sitter's identity is unknown at present. She appears to be an elegant young woman with her hair and clothes in the height of fashion during the first years of Queen Anne's reign.

Enamel on copper: oval, 56 × 45 mm.
Bentinck Hawkins Collection, 1894 [1897.86]. Min. 62

[1] Williamson 1904, II, pl. 85.
[2] Reynolds, forthcoming.
[3] For Boit, see Murdoch 1981, pp. 164–5, and Reynolds 1988, pp. 87–90, fig. 49.

24

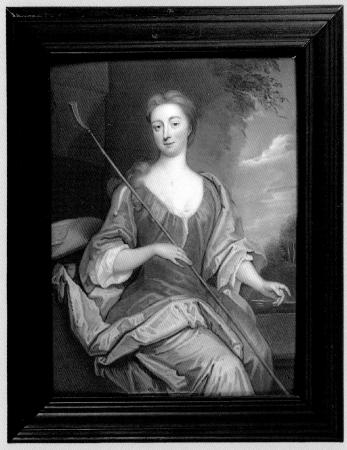

23

29

Style of **Jacqes-Antoine Arlaud** (1668–1746)

25 Prince James Francis Edward, 'The Old
 Pretender'

One of many versions and variants of a portrait painted
by Alexis-Simeon Belle and well-known from a
magnificent line engraving by François Chéreau.[1] A
similar miniature, slightly smaller and painted in oil on
copper, is in the National Portrait Gallery. Arlaud and
his brother Benjamin ran a prolific studio in the exiled
Stuart court at St Germain. Their products were popu-
lar among the Jacobite sympathisers in France,
England and Scotland, and may be found in many pri-
vate collections.

Card: oval, 76 × 61 mm, unframed.
De la Hay Bequest, 1936 [1936.118]. Min. 189

Bernard Lens (1682–1740)

26 Lady in a Green Dress, c.1715–20

Bernard Lens frequently made miniature copies of full
scale portraits by Van Dyck, Lely, Kneller, Dahl and
other artists. Lady in a Green Dress has every appear-
ance of being a copy of a portrait painted in the infor-
mal dress fashion of c.1715–20.

Ivory: oval, 44 × 34 mm, signed in monogram, lower right, in gold:
BL.
De la Hey Bequest, 1936 [1936.125]. Min. 196

27 Self-Portrait, 1724

One of a series of Bernard Lens self-portraits, with oth-
ers at Ickworth, Welbeck and in the National Portrait
Gallery.[2] The Ashmolean version shows the artist, aged
forty-two, holding a miniature of a lady in a blue dress,
a table beside him with drawing-board, palette and
brushes.[3]

Gouache on paper: rectangle, 129 × 98 mm, signed and dated in
monogram, lower left, in gold: BL 1724, and inscr. on the card
reverse: Bernard Lens Pictor Painted by himself born 1682 done
Nov: y 26 1724 / Painter in Miniature to his most sacred Majesty King
George 1st and 2nd / Son of Bernard & Mary Lens Painter in Oyle.
Bentinck Hawkins Collection, 1894 [1897.58]. Min. 34

[1] Kerslake 1977, p. 155.
[2] ibid., p. 167.
[3] Poole I, p. 188, no. 455.

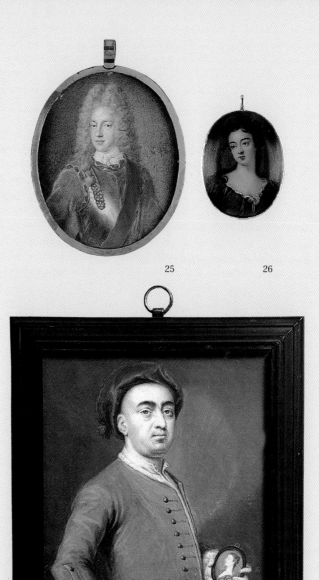

25 26

27

Christian Frederick Zincke (1683/4–1767)

28 Boy in a Blue Coat, 1716

The sitter's identity is unknown at present. Zincke was immensely prolific, labouring with true German industry until well into his seventies. Large collections of his works are in the Royal Collection and at Welbeck, but the Ashmolean specimen appears to be one of the earliest actually signed and dated.[1] A chalk drawing in the British Museum, dated 1752, shows Zincke at work on a miniature, wearing cap and spectacles, at a specially devised easel-desk.[2]

Enamel on copper: oval, 45 × 37 mm, signed and dated *1716* (unconfirmed but probably inscribed on the enamel reverse). Plain gold locket.
Bentinck Hawkins Collection, 1894 [1897.77]. Min. 53

29 Portrait of a Man, called Lord Orford, *c.*1715–20

Edward Russell, Earl of Orford (1652–1717), Admiral of the Fleet.[3] A particularly fine specimen of Zincke's early enamel work, probably painted *ad vivum*. The sitter's identity, however, is doubtful: the portrait of Lord Orford, victor of Cape Barfleur in 1692 and First Lord of the Admiralty, by Thomas Gibson, of *c.*1716, shows an older, more heavily-built man.[4]

Enamel on copper: oval, 39 × 33 mm, inscribed on the mottled enamel reverse: *C. F. Zincke. fecit.60.*
Bentinck Hawkins Collection, 1894 [1897.70]. Min. 46

30 Lady in Sea-Green, *c.*1720

The sitter's identity is unknown at present but the sea motifs of pearls, coral, shells and the sea-green dress itself, suggest she may be the wife or daughter of a naval officer.

Enamel on copper: oval, 43 × 39 mm, framed in a plain gilt-metal locket.
Bentinck Hawkins Collection 1894 [1897.87]. Min. 63

[1] Williamson 1904, II, p. 63.
[2] Black and red chalk drawing by William Hoare, showing Zincke 'amusing himself in painting his own Daughter's picture' (British Museum, P. & D., 1860-7-28-167), repr. Walker 1992, fig. 3.
[3] A printed sale label on the back: *Lord Orford a fine enamel by "Zincke".*
[4] National Maritime Museum, no. BHC299.

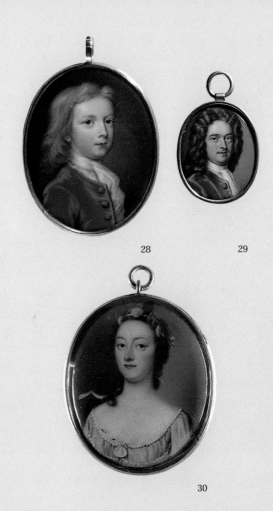

28 29

30

Zincke (continued)

31 Lady Walpole, 1735

Catherine (1682–1737) married in 1700 (Sir) Robert Walpole and was the mother of Horace Walpole, Lord Orford. A sumptuous engraving of this miniature, by George Vertue (1748), was printed as frontispiece to Horace Walpole's *Aedes Walpoleana* (1767).

Enamel on copper: oval, 45 × 38 mm, in a shield-shaped locket decorated with enamel flowers. Prov.: Strawberry Hill sale, 10 May 1842, no. 33.
Bentinck Hawkins Collection, 1894 [1897.88]. Min. 64

32 Lady Ravensworth, *c.*1735

Anne Delmé (1712–94) married in 1735 Sir Henry Liddell, later 1st Baron Ravensworth. The portrait was painted perhaps as a wedding present.

Enamel on copper: oval, 45 × 36 mm, inscribed on the turquoise-coloured reverse: *Anne . . . worth.*
Bentinck Hawkins Collection, 1894 [1897.89]. Min. 65

33 Three Heads

An unfinished enamel from Zincke's studio showing his working technique.

Enamel on copper: oval, 45 × 37 mm, inscr. boldly in black paint on the blue-green enamel reverse: *by C. F. Zincke.*
Presented by Francis Haverfield, 1905 [1905.168]. Min. 150

Gaetano Manini (fl. 1755–75)

34 Frederick, Prince of Wales, 1755

Formerly identified as Edward, Duke of York,[1] this is a posthumous portrait of Frederick, Prince of Wales, the father of George III, based on the portrait of 1741 by Thomas Frye in the Royal Collection.[2] The initials on the reverse of No. 34 may be compared to a similar inscription on Manini's double portrait of the Prince and Princess in 1736, now in the Royal Collection.[3]

Enamel on gold: oval, 36 × 30 mm, inscr. on the white counter-enamel: *P.F.P.D.G.D44,* signed in monogram and dated *GMF 1755.*
Bentinck Hawkins Collection, 1894 [1897.101]. Min. 77

[1] Poole I, p. 190, no. 461; Williamson 1920, p. 34.
[2] Millar 1963, no. 543, pl. 181.
[3] Walker, 1992, no. 708.

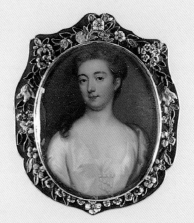

31

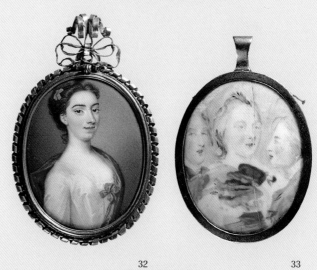

32 33

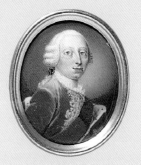

34

Attributed to **Elizabeth Ziesenis** (fl. 1760–80)

35 Augusta, Princess of Wales, 1736

The miniature has a German feeling and may be a copy by Elizabeth Ziesenis from a full scale portrait by her father, Georg Johann Ziesenis, court painter to the royal family in Hanover. The music has not been identified and appears to be to be just a haphazard collection of notes drawing attention to the Princess's talents.

Vellum: octagon, 53 × 72 mm, in an octagonal gold locket.
Presented by Miss H.D.Layton, 1953 [1953.11]. Min. 257

Gervase Spencer (fl. 1740–63)

36 Man in Blue, 1756

The sitter is unidentified at present. He is a stout, expensively dressed man with brown eyes and a supercilious look, aged thirty to forty in 1756.[1] Spencer is classified by Reynolds among the 'modest school' of miniaturists and known to excel in portraits of pretty women painted in cheerful delicate colours.[2]

Enamel: oval, 31 × 26 mm, signed and dated, lower left, in red paint: *GS. 1756*. Plain oval gilt metal locket, unbacked.
Bentinck Hawkins Collection, 1894 [1897.103]. Min. 79

37 Lady in a Blue Dress, 1757

The date engraved on the case suggests a birthday or wedding present. These three miniatures are fine specimens of Spencer's unassuming but highly skilful work on both ivory and enamel.

Ivory: oval, 41 × 34 mm, signed clearly in black paint: *GS 1757*.
Brass case engraved: *May 26: 1757*.
De la Hey Bequest, 1936 [1936.151]. Min. 222

38 Rachael Chumley, *c.*1749

A characteristic and interesting specimen of Spencer's work, handed down in the Church family since it was painted, possibly as a wedding present, in 1749.[3]

Ivory on card: oval, 43 × 35 mm, signed in capitals, lower right: GS inscribed neatly on the backing card: *Rachael Chumley married John elder son of Jeremiah Jedediah Church 1st of June 1749.* Plain oval gold locket, stamped *W*D 18Ct.*
Bequeathed by Dame Jemima Church, 1929 [1929.149]. Min. 231

[1] Described as 'very fine' (Williamson 1904, II, p. 55).
[2] Reynolds 1988, p. 106; Murdoch 1981, p. 170.
[3] Ashmolean Museum, *Annual Report*, 1929, p. 21. Presumably the 'lady on ivory' (Long 1929a, p. 417).

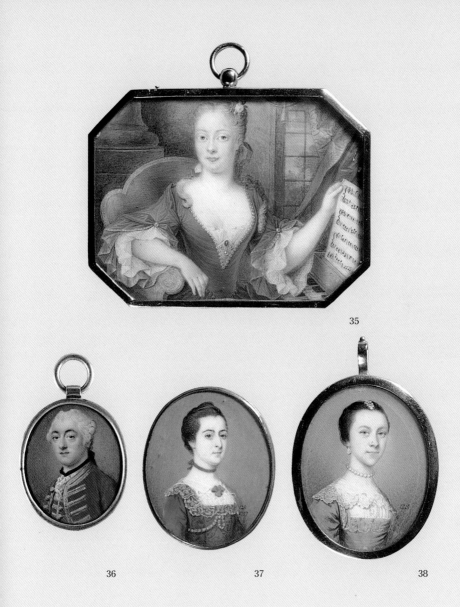

35

36 37 38

Nathaniel Hone (1718–84)

39 Man in a Grey Coat, 1750

The sitter's identity is unknown at present. He appears to be a well-dressed man with brown eyes, a slight smile, aged about thirty in 1750. The miniature is of good quality but, though signed and dated, is not especially typical of Hone's work, which is usually more like oil painting.

Enamel: oval, 45 × 35 mm, signed in monogram and dated, lower left, in black paint: *NH 1750*. Plain oval gold locket.
Bentinck Hawkins Collection, 1894 [1897.104]. Min. 80

Attributed to **Barbara Marsden** (b. 1743)

40 Self-Portrait, *c*.1755

Barbara Marsden won several prizes at the Royal Society of Arts in 1755, 1756 and 1757, for drawings in India ink and chalk, but had to leave 'those amusing pursuits for the more essential duties of a married life'.[1] She married the miniaturist Jeremiah Meyer in 1763. The Ashmolean miniature appears to be the only extant specimen of her work. Elizabeth Paye's portrait of her, aged 59, is No. 82.

Ivory: oval, 43 × 33 mm. Framed in an oval chased locket engraved: *B.M.Nat. 3d June 1743 Gain'd a Premium of 40 Shillings 15 Jany 1755.*
Bequeathed by Mrs Winifred Haverfield,[2] 1920 [1920.66]. Min. 163

[1] Robert Dossie, *Memoirs of Agriculture & other economical Arts*, I (1768), p. 393. I am indebted to the archivist to the Royal Society of Arts, Susan Bennett, for this striking information.
[2] Colonel John Haverfield married in 1815, Barbara Marsden's daughter, Frances Isabella Meyer.

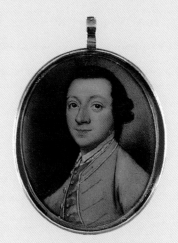

39

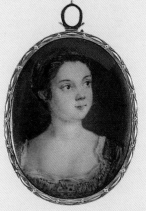

40

Jeremiah Meyer (1735–89)

41 Man in a Blue Coat, c.1770

Meyer was by this time the leading miniaturist in the country.[1] As a fellow-German, he had enjoyed the patronage of the royal family since his portrait of George III's profile for the coinage in 1760, and another as a wedding present for Princess Charlotte of Mecklenburg-Strelitz. It is tempting to identify this miniature as a self-portrait, or perhaps a portrait of his son-in-law, Colonel Haverfield, bequeathed to the Ashmolean after direct family descent.

Ivory: oval, 51 × 43 mm, unsigned.
Bequeathed by Mrs Winifred Haverfield, 1920 [1920.63]. Min. 160

42 Lady in a White Dress, c.1780–85

An unfinished miniature, showing Meyer's brilliant technique, especially in his treatment of the hair and sculptured features, notable characteristics of his style.

Ivory: oval, 43 × 35 mm. Oval gold locket with chased rim.
De la Hey Bequest, 1936 [1936.152]. Min. 223

43 Queen Charlotte, c.1772

One of several Meyer portraits of Queen Charlotte painted at Windsor in the 1770s. A finished variant, showing the sitter wearing a slightly different head-dress and a sky-blue dress, is at Windsor; a drawing for this is in the Ashmolean.[2]

Ivory: oval in rectangle, 53 × 46 mm, inscribed in pencil on the backing card: *a sketch from life of Queen Charlotte by Jer. Meyer R.A.* Gilt metal rectangular frame backed with purple velvet.
Bequeathed by Mrs Winifred Haverfield, 1920 [1920.60]. Min. 157

44 Georgiana, Duchess of Devonshire, c.1775

One of several unfinished watercolour sketches of the Duchess. A variant, also unfinished and wearing a volu-minous head-dress, is in the Royal Collection.[3] Meyer's final version is at Chatsworth.

Ivory: oval, 97 × 80 mm, in an oval gold locket.
Bequeathed by Mrs Winifred Haverfield, 1920 [1920.56]. Min. 153

[1] Reynolds 1988, pp. 115–8.
[2] Walker 1992, no. 255; Brown 1982, no. 1361.
[3] Walker 1992, no. 266.

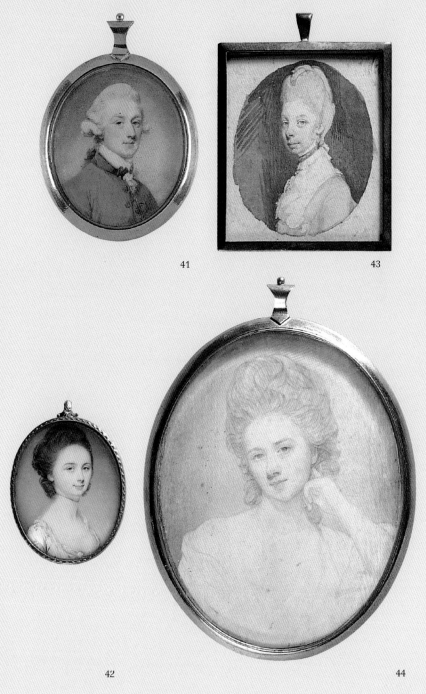

41

43

42

44

41

Gervase Spencer (fl 1740–63)

45 Dr Wollaston, c.1760–63

The sitter is probably Dr George Wollaston (1738–1816), cleric and mathematician, and the portrait was possibly painted to celebrate his election as Fellow of the Royal Society in 1763.

Enamel: oval, 38 × 30 mm (sight). Oval gilt-metal easel-frame engraved: *Dr Woollaston*.
Bentinck Hawkins Collection, 1894 [1897.83]. Min. 59

Henry Spicer (1743–1804)

46 Man in a Green Coat, c.1765–70

Spicer, a Norfolk man, produced almost entirely enamel miniatures, was appointed Enamel Painter to the Prince of Wales in 1785, and painted a remarkable portrait of Marie-Antoinette in 1789.[1]

Enamel: oval, 30 × 25 mm. Signed, lower right, in capital letters: *HS*.
Oval gold locket with chased rim.
Bentinck Hawkins Collection, 1894 [1897.107]. Min. 83

47 Army Officer, c.1780

The sitter appears to be a young Guards officer of about 1785, painted when the popularity of enamel portraits was waning.

Enamel on brass: oval, 32 × 26 mm, uninscribed on plain white counter-enamel.
Bentinck Hawkins Collection 1894 [1897.117]. Min. 93

John Smart (1741–1811)

48 Man in a Red Coat, 1769

The sitter appears to be a well-dressed man of about fifty in 1769. The Smart characteristics are apparent here: neat meticulous brush-strokes, clear colouring, and precise initials and date.[2] Smart was one of the great English eighteenth century miniaturists, who 'had no truck with the frills and graces, yet achieved a sparkling prettiness'.[3]

Ivory: oval, 39 × 32 mm, signed and dated in black paint: *J.S. 1769*.
Bequeathed by C.D.E Fortnum, 1899 [CDEF.1899.438]. Min. 143

[1] Private collection (see Foskett 1987, pp. 295–6, 654).
[2] mentioned in Williamson 1904, II, p. 6, and Long 1929a, p. 407.
[3] Piper 1992, p. 165.

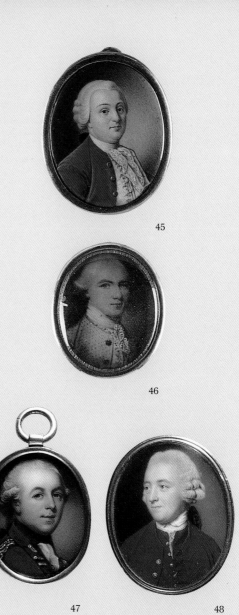

45

46

47 48

John Smart (continued)

49 Mr Plomer, c.1779

The sitter is probably William Plomer, alderman and antagonist of the Lord Mayor of London, Samuel Plumbe, satirised by Gillray and others in 1779. The miniature is a typical sketch made by Smart as a preliminary study for a finished portrait which doubtless exists somewhere but has not yet been located.[1]

Ivory: oval, 52 × 44 mm, framed in locket engraved: *Mr Plomer by John Smart.*
Presented by T.H.Cobb, 1936 [1936.57]. Min. 169

50 Sir George Armytage, Bart, c.1780

Sir George Armytage, 3rd Baronet (1734–83), M.P. for York between 1761 and 1768, and Sheriff of York in 1775–6. As with No. 49, Smart's finished miniature probably exists.[2]

Paper: oval, 54 × 43 mm, framed in an oval gold locket engraved: *Sir G. Armytage Bart. by John Smart.*
Presented by T.H.Cobb, 1936 [1936.58]. Min. 170

51 Sarah Buxton, 1777

Sarah Buxton (born c.1757) married Charles Dumbleton who took his B.A. in 1775. The miniature descended in the Dumbleton family until it was given to the Ashmolean in 1947.[3] Another version was sold by the artist's great-granddaughter, Mrs Busteed, at Christie's, 17 December 1936, lot 25.

Ivory: oval, 40 × 34 mm, signed and dated, lower left: *J.S. 1777.* Plain oval gold locket.
Presented by Miss I.G.Dumbleton, 1947 [1947.273]. Min. 248

52 Mary Smart, 1808

Mary Norton (1783–1851), married John Smart as his third wife in 1805. Three sketches are known: two earlier variants of this miniature (with different low-cut dress and necklace) are both signed and dated 1806.[4] Another, dated 1809, bears the monogram *M S*.[5]

Ivory: oval, 85 × 68 mm, signed and dated, lower right: *J.S. 1808.* Plain oval gold rim with gun-metal back, inscribed indistinctly in ink: *by John Smart.*
De la Hey Bequest, 1936 [1936.144]. Min. 215

[1] 'Mr Plomer, dated 1779 and sketch', Foskett 1964, p. 72.
[2] Smart's miniature of him, in a grey-green coat, was sold by Mrs Dyer, the artist's great-granddaughter, at Christie's, 26 November 1937, lot 7.
[3] Ashmolean Museum, *Annual Report*, 1947, p. 41; Foskett 1964, p. 66.
[4] Mrs K.Gifford Scott collection, exh. Edinburgh 1965, no. 24; Lt Col. D.C.Pulley, sold Sotheby's, 26 November 1986, lot 150.
[5] sold by Mrs Busteed at Christie's, 17 December 1936, lot 46.

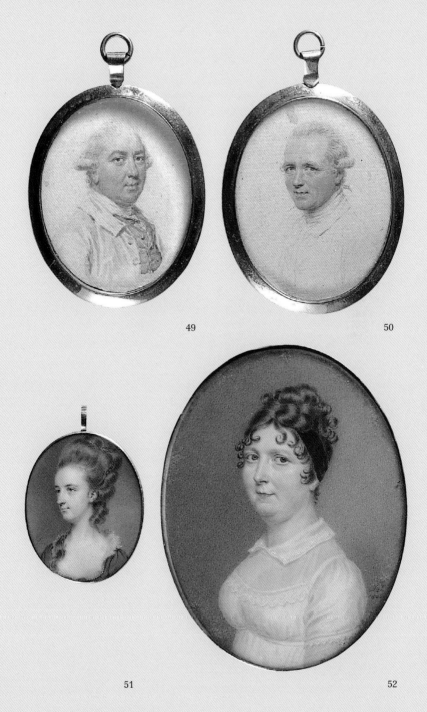

49

50

51

52

Richard Cosway (1742–1821)

53 Young Man in a Brown Coat, 1780s

The sitter is a young man of eighteen to twenty in about 1780.[1] This is an example of Cosway at his best, shortly before he was taken up by fashionable London society including Mrs Fitzherbert and the Prince of Wales himself.[2] 'His characters are winsome with enormous melting eyes, a little hectic in the cheek and with a calculated negligence in the hair, sometimes their heads are almost as wide as the shoulders; but they are presented with such three-dimensional skill that they convince.'[3]

Ivory: oval, 39 × 33 mm, in a plain locket with glass back and plaited hair.
De la Hey Bequest, 1936 [1936.149]. Min. 220

54 John Norris of Hughenden, *c.*1795–1800

John Norris (d. 1845), scholar and antiquary whose family had owned and lived at Hughenden Manor since it was sold by Lord Chesterfield in about 1750;[4] three years after his death in 1845, it was acquired by Benjamin Disraeli, later Prime Minister. These two miniatures demonstrate very clearly Cosway's preoccupation with creating the illusion of a third dimension by means of modelling with long curved brush-strokes, his transparent colour and the use of Antwerp blue in the sky backgrounds.

Ivory: oval, 69 × 52 mm, in a paste diamond frame with machined gold back and an oval window revealing brown silk.
Presented by Miss I.G. Dumbleton, 1947 [1947.272]. Min. 247

George Engleheart (1750–1829)

55 Miss Brooke, *c.*1780

Engleheart was immensely prolific and his fee-book is still in the Engleheart family possession. The sitter's costume and hair style suggest a date in the early 1780s.[5] The fee-books certainly record payments for 'Miss Brook 1786, Miss Brooks 1791 and 1792', and several other members of the Brook, Brooke, and Brooks families, between 1786 and 1792.[6]

Ivory: oval, 37 × 31 mm, signed at right with the initial: *E* (or *C*).
Plain gold frame with printed label: *Miss Brooke*.
Bentinck Hawkins Collection, 1894 [1897.65]. Min. 41

[1] 'The Rev. M. de la Hey has three miniatures by Cosway, including two early ones' (Long 1929, p. 100).
[2] Lloyd 1995.
[3] Piper 1992, p. 184.
[4] Ursula Larmuth, *The Norris Family* (Tenby Museum, 1986); *National Trust Guide to Hughenden Manor* (1988), p. 4.
[5] Long 1929, p. 142, dates the miniature to *c.*1778.
[6] Williamson & Engleheart, pp. 87–8.

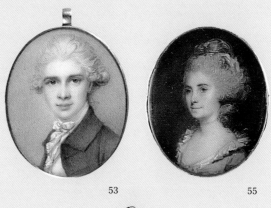

53 55

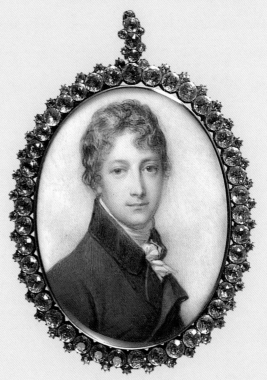

54

47

56 Sir Richard Symons, c.1787

Sir Richard Peers Symons (c.1744–96), M.P. for Hereford between 1768 and 1784, created Baronet in 1774, and died unmarried. His name appears in Engleheart's fee-book under the year 1787.[1]

Ivory: oval, 45 × 37 mm. Plain gold locket with plaited brown hair surrounding a nacre enamel oval with gold monogram: *RPS*.
Bequeathed by the Revd Dr H.E.D.Blakiston, 1942 [1942.7]. Min. 242

57 Anna Sophia Blunt, c.1785

Anna Sophia (1765–1845), eldest child of Sir Charles and Elizabeth Blunt. She died unmarried. The miniature is more delicately modelled than those of her brother and brother-in-law (Nos. 58–9), and shows Engleheart's typically crisp treatment of the white dress and straw hat. The fee-book records payments from 'Miss Blunt' in 1785, 1787, 1792 and 1793.[2]

Ivory: oval, 65 × 54 mm. Plain gold locket with glass window displaying plait of dark brown hair.
Bequeathed by the Revd Dr H.E.D.Blakiston, 1942 [1942.4]. Min. 239

58 Sir Charles Blunt, 3rd Baronet, 1790s

Charles Blunt (1731–1802), third son of Sir Henry Blunt, whom he succeeded as 3rd Baronet in 1759, married Elizabeth Peers in 1767. They had three sons and nine daughters. Engleheart's published fee-book records payments from several of the family between 1785 and 1812 but not from Sir Charles himself. A miniature of Lady Blunt by Engleheart, signed and dated 1794, was sold at Christie's on 4 July 1989, lot 307. A miniature of Sir Charles himself, by George Place, c.1790, was sold at Christie's on 25 November 1975, lot 29.

Ivory: oval, 85 × 70 mm, signed, lower right, with a cursive: *E*. Plain gold frame backed with brown silk.
Bequeathed by the Revd Dr H.E.D.Blakiston, 1942 [1942.2]. Min. 237

[1] Williamson & Engleheart 1902, p. 113; Long 1929, p. 142.
[2] Williamson 1902, pp. 87–9.

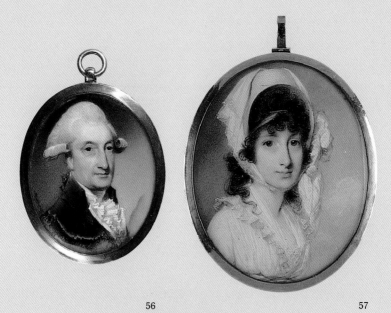

56 57

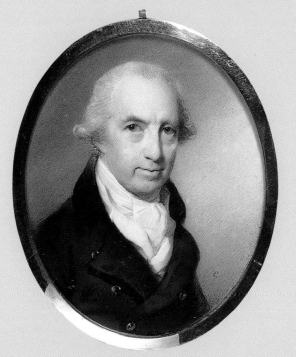

58

George Engleheart (continued)

59 Sir Charles Burrell Blunt, 1798

Charles Burrell Blunt (born *c*.1775), married Elizabeth,
fifth daughter of Sir Charles and Lady (Elizabeth) Blunt.
He joined the 15th (King's) Regiment of Light Dragoons
in 1795 and retired as a captain in 1800. He distin-
guished himself in 1794 and was awarded a gold medal
and the Order of Maria Theresa, which he wears on his
Light Dragoon uniform. Engleheart's fee-books record
a payment from Captain Blunt in 1798, the year the
award was gazetted.[1]

Ivory: oval 80 × 63 mm. Plain oval frame (hanger broken) with plait-
ed fair hair.
Bequeathed by the Revd Dr H.E.D.Blakiston, 1942 [1942.1]. Min.
236

60 Elizabeth Blunt, *c*.1796–1800

The sitter is probably Elizabeth (born *c*.1766; died
unmarried), second daughter of Sir Charles and Lady
Blunt. She seems to be aged about twenty but her
clothes and hair style suggest a date of *c*.1795. She
appears in the fee-books for the years 1796 and 1800.[2]

Ivory: oval, 65 × 52 mm. Plain oval gold locket.
Bequeathed by the Revd Dr H.E.D. Blakiston, 1942 [1942.3]. Min.
238

61 Maria Tryphena Blunt, *c*.1785–9

Maria Tryphena (*c*.1769–89), fourth daughter of Sir
Charles and Lady Blunt. She married in 1789, as his first
wife, Sir Charles Cockerell of Sezincote, and died in the
same year. A duplicate miniature is also in the Ash-
molean (Min. 241), another in the Fitzwilliam Museum,
Cambridge (no. 3759), and a third was sold at Christie's,
3 October 1972, lot 141. Sir Charles's second wife,
Harriet Rushout, was painted by Plimer and Cosway.

Ivory: oval, 52 × 45 mm. Plain gold locket.
Bequeathed by the Revd Dr H.E.D.Blakiston, 1942 [1942.5]. Min.
240

[1] See Introduction,
pp. 12–13; Williamson
& Engleheart 1902,
p. 88. For his portrait
by Edridge, see *ibid*,
p. 6, note 1.
[2] *ibid*., pp. 87–8.

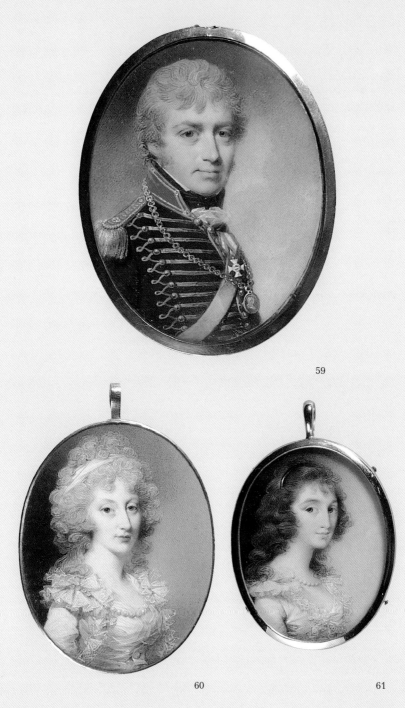

59

60 61

51

Henry Edridge (1768–1821)

62 Lydia or Elizabeth Blunt, c.1795

Henry Edridge, a skilful and much-neglected artist, needs a monograph of his own. An interesting group of his miniatures of the Hoare family is at Stourhead, and several of his elegant whole-length drawings are in the Royal Collection.[1] Lydia and Elizabeth were the youngest of the twelve children of Sir Charles and Elizabeth Blunt. Family tradition, as inscribed on the backing paper, attributed this miniature to Engleheart, but the style strongly suggests Edridge.[2]

Ivory: oval, 65 × 50 mm. Gold painted card mount with paper.
Bequeathed by the Revd H.E.D.Blakiston, 1942 [1942.9]. Min. 244

63 Anna Maria Blunt, c.1795

As with the portrait of her sister (No. 62), this miniature was formerly attributed to Engleheart but is almost certainly by Edridge.

Ivory: oval, 68 × 53 mm. Oval gold and cornelian mount.
Bequeathed by the Revd H.E.D.Blakiston, 1942 [1942.10]. Min. 245

Attributed to **Patrick McMorland** (1741–after 1809)

64 Elizabeth Reed, c.1775

Possibly Elizabeth Buchanan, wife of Thomas Reed of Dublin (see Min. 249). The miniature was formerly ascribed to Ozias Humphry,[3] but both John Murdoch and Jim Murrell have suggested McMorland.

Ivory: oval, 42 × 32 mm. Oval gold red-locket with window panel and ornate gold monogram *ER* on white enamel.
Presented by Miss I.G.Dumbleton, 1947 [1947.275]. Min. 250

Attributed to **Ozias Humphry** (1742–1810)

65 Man in a Grey Coat, c.1785

The miniature was formerly ascribed to the 'French School', but Mrs Foskett has convincingly suggested Ozias Humphry.[4]

Ivory: oval, 39 × 30 mm. Oval gold locket in a blue enamel surround, with plaited brown hair and pearls in the back.
Bentinck Hawkins Collection, 1894 [1897.147]. Min. 123

[1] A.P.Oppé, *English Drawings in the Collection of His Majesty the King at Windsor Castle* (London, 1950), pp. 45–9.
[2] Long 1929, p. 138. Henry Bone's preliminary drawing for an enamel inscribed, 'Mr Blunt after Edridge, for Lady Blunt 1799', is in the National Portrait Gallery, Bone album, III.4.
[3] Ashmolean Museum, *Annual Report*, 1947, p. 41.
[4] Reynolds 1988, pp. 134–9; Walker 1992, pp. 117–21.

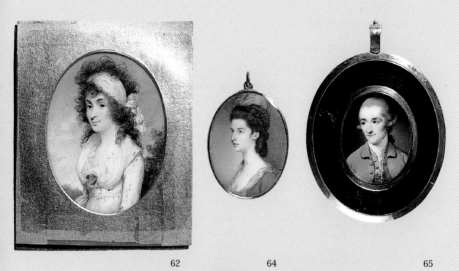

62 64 65

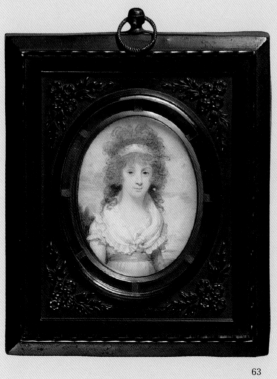

63

Attributed to **Diana Dietz** (d. 1844)

66 Lady in a White Bonnet, 1778

The artist signing with the initials *DD* is usually thought
to be either Diana Dietz or Daniel Dodd, both of whom
exhibited in London at about this time. The three
Ashmolean miniatures were seen by Long and tenta-
tively ascribed to Dietz. Most students have followed
this line, though both John Murdoch and Jim Murrell
were doubtful in 1983. The sitters appear to be mother,
daughter and granddaughter, freely if coarsely painted,
but with considerable panache.

Ivory: oval, 37 × 30 mm, signed and dated, lower left, in white paint:
DD 78. Plain oval gold locket.
Bequeathed by Dame Jemima Church, 1929 [1929.152]. Min. 234

67 Lady in a Red Dress, 1778

Presumably the daughter of the lady in No. 66.

Ivory: oval, 38 × 32 mm, signed and dated, lower left, in white paint:
D 78. Framed to match No. 66.
Bequeathed by Dame Jemima Church, 1929 [1929.151] Min. 233

68 Child holding flowers, 1778

Presumably the daughter of the lady in No. 67.

Ivory: oval, 37 × 30 mm, signed and dated, lower left, in white paint:
DD P78. Framed to match No. 66.
Bequeathed by Dame Jemima Church, 1929 [1929.150]. Min. 232

Attributed to **Christopher William Honeyman**

69 Self-Portrait, *c*.1765–70

The engraved inscription on the locket is highly suspect
but the subject is presumably C.W. Hunnemann, son of
the Court physician in Hanover, copyist and, according
to Mrs Papendiek, 'also a good miniaturist'.[1] He angli-
cised his name to Honeyman and is known to have
copied the royal portraits by Gainsborough in 1786.
The miniature was formerly described as an early work
by Samuel Shelley,[2] but Honeyman himself is suggested
here.

Ivory: oval, 37 × 29 mm. Framed in a chased gold bracelet-locket en-
graved: *George Honeyman Painter to King George III by Cosway*.
Bentinck Hawkins Collection, 1894 [1897.60]. Min. 36

[1] *Court and Private Life
in the Time of Queen
Charlotte: being the
journals of Mrs Papen-
diek*, ed. Mrs V.D.
Broughton (1887), I,
p. 200.
[2] Long 1929, p. 100.

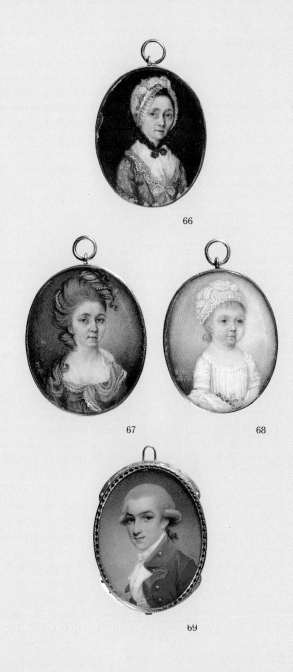

66

67 68

69

Studio of Van Blarenberghe

70 Parachute Descent, 1783

Louis-Sébastien Lenormand (1757–1839) descended by parachute from the tower of Montpellier observatory, hoping it might lead to a practical fire escape. The Blarenberghe family delighted in such scenes, painting them often on expensive gold boxes.[1]

Gouache on vellum: oval, 52 × 45 mm, inscribed on the cartouche: *S. Lenormand Inventeur du Parachute 1783.*
De la Hey Bequest, 1936 [1936.121]. Min. 192

71 Balloon Ascent, 1784

The portraits are of J.F.Pilâtre de Rozier and Pierre Romain. Pilâtre de Rozier made a pioneering ascent from the Bois de Bologne in 1783, followed a year later in England by Vincent Lunardi.

Gouache on vellum: circle, 57 mm, inscribed on the cartouche: *Pilatre de Rozier. 1784 Pierre Romain.*
Bentinck Hawkins Collection, 1894 [1897.148]. Min. 124

Attributed to **Marie-Anne Gérard, Mme Fragonard** (1745–1823)

72 Portrait of a Child, *c.*1780

One of a number of freely-painted miniatures of children associated with Fragonard's wife, Anne-Marie Gérard, who exhibited miniatures at the Paris Salon between 1779 and 1782.[2]

Ivory: rectangle, 88 × 63 mm.
Presented by Chambers Hall, 1855 [1855.209]. Min. 144

Le Chevalier de Châteaubourg (*c.*1765–*c.*1835)

73 Lady in a Grey Dress, 1796

She is believed to be the actress Mlle Bourgoin, as 'Roxelane' in *Les Trois Sultannes*, though one would have expected her to be wearing Turkish costume in this role.

Ivory: circle, 80 mm, signed and dated, lower left: *Le Chr De Châteaubourg pinxit 1796.* Plain gold frame backed with dark brown plaited hair and with cor anglais hanger.
Presented by Miss Daphne White in memory of Frank and Pauline Taussig and Mary Kupfer, 1989 [1989.87]. Min. 324

[1] Interesting Van Blarenberghe boxes are in the Wallace Collection and at Waddesdon Manor; but undoubtedly the best are in the Edmond de Rothschild Collection at the Louvre.
[2] A similar portrait of *An Unknown Girl* is in the Wallace Collection (Reynolds 1980, no. 91), classified among a group of freely painted miniatures traditionally associated with the name of Fragonard. For others of this group, see Rosenberg.

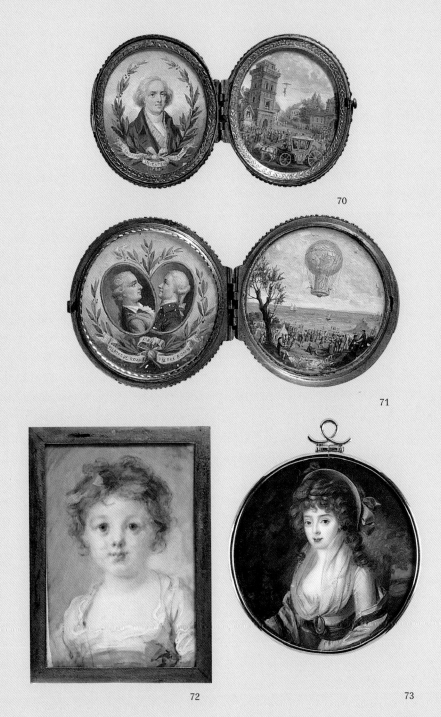

70

71

72

73

57

Andrew Plimer (1763–1837)

74 Man in a Brown Coat, 1790s

The sitter's identity is unknown at present. He appears to be a middle-aged man in c.1795.[1] His swarthy, gipsy-like face is modelled with the bold brush-strokes characteristic of Plimer's work at this time.

Ivory: oval, 77 × 61 mm. Gold brooch-locket backed with glass over plaited brown hair.
Bentinck Hawkins Collection, 1894 [1897.62]. Min. 38

75 Young Man in a Brown Coat, 1790

The sitter is possibly the son of the man in No. 74.

Ivory: oval, 69 × 54 mm. Oval gold locket backed with white silk.
Bentinck Hawkins Collection, 1894 [1897.63]. Min. 39

76 Captain Price, c.1800

The exact identity of Captain Price is uncertain at present. He was probably the Dunbar Hamilton Price who joined the army as an ensign in 1782 and was appointed a captain in the 5th Dragoon Guards in 1797. The Army Lists lose sight of him after 1800, the approximate date of this miniature, which is unsigned, but the large oval ivory, the long nose, wide-open eyes, and dark colouring are typical of Plimer's work after the 1790s.[2]

Ivory: oval, 75 × 61 mm. Plain brass frame with clawed back.
Bentinck Hawkins Collection, 1894 [1897.64]. Min. 40

Joseph Bowring (c.1760–after 1817)

77 Naval Officer, c.1795

The sitter's identity is unknown at present but the background ship suggests either a naval or merchant navy officer of the late 1790s with the initials ES. Long noticed the miniature when in the collection of the Revd Martin de la Hey.[3] A Bowring miniature of a similar man, but wearing a brown coat, was sold at Sotheby's, 28 April 1975, lot 41.

Ivory: oval, 70 × 55 mm, signed, left, in monogram: JB. Plain gold locket with blue glass back and monogram ES.
De la Hey Bequest, 1936 [1936.140]. Min. 211

[1] 'At the Ashmolean Museum are three miniatures of men which are reasonably ascribed to Plimer' (Long 1929a, p. 345).
[2] Williamson 1903, pp. 87–8.
[3] 'Two miniatures signed with Bowring's monogram JB, in which the J prolongs in either direction the vertical stroke of the B . . . very minute stippling in the face' (Long 1929a, p. 44).

74

75

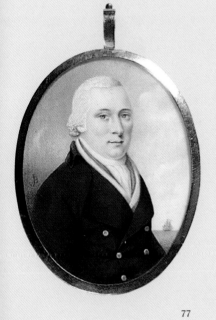

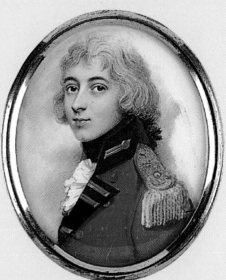

77

76

59

John Comerford (c.1770–1832)

78 Volunteer Officer, c.1800

This unidentified officer was probably in an Irish light infantry volunteer regiment.[1]

Ivory: oval, 83 × 64 mm, signed, lower right: *J. Comerford.* Plaited hair in black and white enamel back.
De la Hey Bequest, 1936 [1936.155]. Min. 226

Abraham Daniel (d. 1806)

79 Dr Henry Harington, c.1780

Henry Harington (1727–1816), physician, musician, and founder of the Bath Harmonic Society.[2]

Ivory (cracked): oval, 94 × 77 mm, inscribed on the backing card in ink: *Dr Harrington,* and the sprawling initials *AD.*
De la Hey Bequest, 1936 [1936.132]. Min. 203

80 Young Man in Academic Dress, c.1800

Probably an Oxford undergraduate who visited the Daniel studio in Bath to celebrate his degree.

Ivory: octagon, 81 × 53 mm, in a plain octagonal gold frame.
De la Hey Bequest, 1936 [1936.142]. Min. 213

Charles Hayter (1761–1835)

81 Dorothy Blunt, c.1800

Dorothy (1733–1809) was a sister of Sir Charles Blunt and an aunt of his twelve children (Nos. 57–63).

Chalk on paper: oval, 125 × 96. Inscribed in ink: *Dorothy Blunt d. of Sir Blunt 2nd Bart 1733–1809 . . . "Aunt Dorothy".*
Bequeathed by the Revd Dr Blakiston, 1942 [1942.8]. Min. 243

Elizabeth Anne Paye (fl. 1798–1807)

82 Barbara Meyer, 1802

Barbara Marsden (b. 1743) (see No. 40) married the miniaturist Jeremiah Meyer in 1763 (see No. 41).

Ivory: oval, 84 × 64 mm, inscribed neatly on the backing card: *Barbara Meyer aged 59 Eliza Anne Paye Pinxit 1802 revived 1833 – by Apollonia Griffith Glocester (?) Grandaughter of the above Barbara Meyer.* Gilt metal frame with velvet backing.
Bequeathed by Mrs Winifred Haverfield, 1920 [1920.67]. Min. 164

[1] Comerford's sitter-book (1802–28) is in library of the National Portrait Gallery; a list of his sitters appears in Strickland's *Dictionary of Irish Artists* (1913), I, pp. 197–202.
[2] Long noticed this miniature when in the collection of the Revd Martin de la Hey, then a Fellow of Keble College (Long 1929, p. 115).

78 79 80

81 82

William Wood (1769–1810)

83 Man in a Black Coat, *c.*1805–07

William Wood's sitter-book is in the National Art Library, but it has not yet been possible to identify the sitter, a man of about fifty in *c.*1805, with the initial D.

Ivory: oval, 79 × 61 mm, inscribed by the artist on the backing card: *By Will: Wood of Cork Street, London.*
De la Hey Bequest, 1936 [1936.123]. Min. 194

Andrew Robertson (1777–1845)

84 Man in a Black Coat, 1808

The sitter appears to be about fifty in 1808, with dark green eyes and initials WR, and may perhaps be the artist's father, the architect William Robertson.[1]

Ivory (warped): oval, 89 × 70 mm, signed and dated, lower right, in black paint: *AR 1808,* the backing card with a plait of brown hair and inscribed with the initials *WR.* Plain oval gilt-metal rim.
De la Hey Bequest, 1936 [1936.134]. Min. 205

85 Archdeacon Philpot, 1841

Previously identified as Henry Phillpotts, bishop of Exeter,[2] but bears no resemblance to his authenticated portraits by Cruikshank, Woolnoth and J.P.Knight.[3] Robertson exhibited the miniature at the R.A. in 1842 as 'Archdeacon Philpot' which would suggest Benjamin Philpot (1790–1889), Fellow of Christ's College, Cambridge, and Archdeacon of Sodor and Man.

Ivory: rectangle, 135 × 107 mm, signed and dated: *AR 1841.*
Bentinck Hawkins Collection, 1894 [1897.124]. Min. 100

W. Hatfield (fl. 1780)

86 Dr Samuel Johnson

No. 86 is a variant of Reynolds's portrait of 1773 (Tate Gallery). Although purporting to be a miniature, it is in fact a stipple engraving by Holl, transferred to copper and enamelled by Hatfield.[4]

Enamel on copper: oval, 98 × 85 mm, inscribed on the white counter-enamel in large black letters: *Samuel Johnson born at Lichfield 1709 Dead in London 1784. W.Hatfield Enameler 1780.*
Bentinck Hawkins Collection, 1894 [1897.112]. Min. 88

[1] Long noticed this miniature when in the collection of the Revd Martin de la Hey (Long 1929a, p. 367).
[2] Poole I, p. 198, no. 485; Long also recorded this miniature, and assumed it did represent the Bishop of Exeter.
[3] John Ingamells, *The English Episcopal Portrait 1559–1835* (York, 1981), p. 326.
[4] Noticed in the Ashmolean by Williamson 1904 II, p. 65, Long 1929, p. 195, and Foskett 1987, p. 559. Holl's engraving was used as frontispiece to Longman's edition of Johnson's *Dictionary* (1814).

83

85

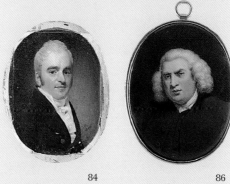

84

86

63

Charles Bestland (fl. 1783–1837)

87 Sir Joshua Reynolds

A copy of a portrait by Gilbert Stuart of 1784.[1] Bestland's 'new Permanent manner' is not documented but appears to have been simply liquid oil paint used on a primed copper base and fixed with gum arabic.

Oil on copper: rectangle, 149 × 119 mm, signed in cursive script: *Painted in a new Permanent manner. C.Bestland, Pinxit.* The copper back engraved: *T.Large – Junr Little-New St. Shoe-Lane London.* Bentinck Hawkins Collection, 1894 [1897.57]. Min. 33

William Hopkins Craft (c.1730–1811)

88 Sir William Hamilton, c.1802

No. 88 is a copy of a painting by Charles Grignion of 1799.[2] Another version by Craft, signed and dated 1802, is in the British Museum,[3] and a third was sold at Sotheby's, 1 March 1965, lot 35.[4]

Enamel on copper: oval, 171 × 138 mm, inscribed in neat black script: *The Rt Honble Sr Wm Hamilton. W.H.Craft, fect.* Bentinck Hawkins Collection, 1894 [1897.106]. Min. 82

89 Sir Joshua Reynolds, 1786

Reynolds's self-portrait of c.1780 in the Royal Academy was copied frequently by Henry Bone and others.[5]

Enamel on copper: oval, 173 × 140 mm, inscribed on the white counter-enamel in neat black script: *Portrait of Sir Joshua Reynolds President of the Royal Academy. Instituted 1769. Member of the Imperial Academy of Florence Doctor in Laws of the Universities of Oxford and Dublin, and FRS. WH Craft fect 1786.* Bentinck Hawkins Collection, 1894 [1897.105]. Min. 81

William Russell Birch (1755–1834)

90 Earl of Mansfield, 1793

William Murray, 1st Earl of Mansfield (1705–93), Lord Chief Justice for 32 years. A copy of Reynolds's portrait of 1776, still in the family collection. Another enamel version, also signed and dated 1793, was sold at Christie's, 10 November 1993.

Enamel: oval, 118 × 104 mm, signed and dated, lower right, neatly in gold paint: *W Birch 1793.* Bentinck Hawkins Collection, 1894 [1897.108]. Min. 84

[1] National Gallery of Art, Washington, no. 574.
[2] Painted in Palermo 1799, versions at Lennoxlove and Royal Naval Museum, Portsmouth, repr. Brian Fothergill, *Sir William Hamilton Envoy Extra-ordinary* (1969), and in Oliver Warner, *Emma Hamilton and Sir William* (1960).
[3] Poole I, p. 193, no. 467; repr. in Aubrey J.Toppin, 'William Hopkins Craft, Enamel Painter', *Transactions of the English Ceramic Circle*, IV pt iv (1959), pp. 14–18, pl. 13–14.
[4] Foskett 1987, pl. 74D and fig. 27. A chalk version inscribed 'Sir Wm Hamilton by Gainsborough' and attributed to Hugh Douglas Hamilton, was in the Castle Howard sale, Sotheby's, 12 November 1991, lot 531.
[5] Bone's copy of 1804 is in the Royal Collection (Walker 1992, no. 783).

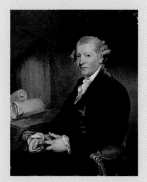

87

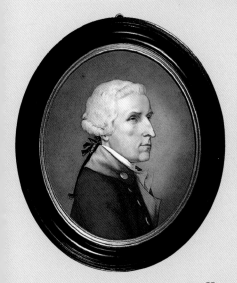

88

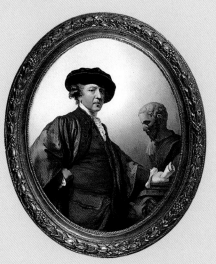

89

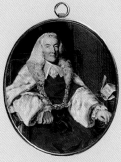

90

Samuel John Stump (1778–1863)

91 Augustus, Duke of Sussex, 1804

Long and Foskett describe Stump's work as 'prolific and mediocre', or 'rather dull', but both this miniature and one of the Duke's elder brother, George IV, have considerable charm and originality.[1]

Ivory (split at right): rectangle, 108 × 82 mm, signed and dated in red paint: *SJStump 1804*. Gilt mount in wooden frame.
Bentinck Hawkins Collection, 1894 [1897.119]. Min. 95

Attributed to **George Place** (d. 1805)

92 John Flaxman, *c*.1798

Traditionally attributed to Place, this could be the miniature by Thomas Arrowsmith exhibited at the R.A. in 1798 (no. 765). Arrowsmith's work was described by Long as an imitation of Cosway with opaque white on the hair.[2]

Ivory: oval, 84 × 67 mm.
Bentinck Hawkins Collection, 1894 [1897.66]. Min. 42

Moses Haughton (1772/4–1848)

93 Henry Fuseli, *c*.1808

Haughton painted several miniatures of Fuseli. Leigh Hunt described them in his autobiography: 'he is sitting back in his chair leaning on his hand, but looking ready to pounce withal'.[3]

Ivory: oval, 58 × 50 mm. Engined brass frame with backing paper inscribed in ink: *H.Fuseli R.A. P*^t *1825*.
Prov.: Countess of Guilford; Carrick Moore; George Heath, and by descent. Presented by P.G.Heath, M.C., 1948 [1948.179]. Min. 253

Henry Bone (1735–1844)

94 George IV, 1805

George IV when Prince of Wales, in uniform as Colonel of the 10th Light Dragoons. A copy by Bone of the portrait by Madame Vigée-Le Brun, given by the Prince to Mrs Fitzherbert.[4]

Enamel on copper: oval, 165 × 133 mm, signed and dated, lower right: *HBone 1805*. Unframed.
Bentinck Hawkins Collection, 1894 [1897.111]. Min. 87

[1] Stump's *George IV* repr. Walker 1992, p. lxxii.
[2] Long 1929, p. 8.
[3] Leigh Hunt, *Autobiography* (1850), I, p. 214.
[4] Collection of Lord Portarlington.

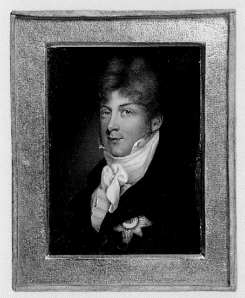

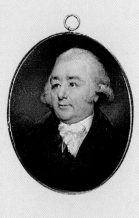

91

92

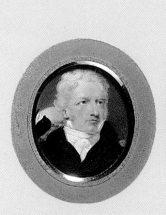

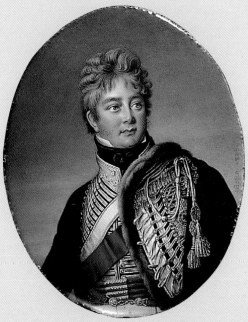

93

94

William Essex (1784–1869)

95 Queen Victoria, 1839

A variant copy (without the crown) by Essex, of the state portrait by Hayter in Holyroodhouse.[1]

Enamel on gold: oval, 46 × 37 mm, inscribed neatly on the white counter-enamel: *VR 1839 Painted after G.Hayter by W.Essex Enamel Painter to Her Majesty.* Plain oval gold frame.
Bentinck Hawkins Collection, 1894 [1897.137]. Min. 113

Henry Pierce Bone (1779–1855)

96 Prince Albert, 1842

A copy of the head from Winterhalter's original of 1842 in Windsor Castle.[2] He wears the undress uniform of a Field Marshal and the Golden Fleece.

Enamel on gold: oval, 49 × 38 mm, lavishly inscribed on the white counter-enamel in purple paint. Plain oval brass frame.
Bentinck Hawkins Collection, 1894 [1897.129]. Min. 105

Attributed to **Mary Ann Knight** (1776–1851)

97 Girl in a White Dress, *c.*1815

The sitter appears to be a young woman of about twenty, between 1810 and 1820. Williamson declared this was 'the finest work I have seen by Mary Ann Knight'.[3] Long was not so sure and classified it as 'attributed to Mary Ann Knight'.[4] The white ground hatched with brown, and the sfumato and gipsyish look, certainly show the influence of Plimer, whose pupil she was.

Ivory: rectangle, 84 × 65 mm.
Bentinck Hawkins Collection, 1894 [1897.118]. Min. 94

Jean-Baptiste-Jacques Augustin (1759–1832)

98 Duc de Berry, 1814

Charles Ferdinand, duc de Berry (1778–1820), 2nd son of Charles X of France. From 1801, he lived in England, married Anna Brown and had two daughters. A variant is also in the Ashmolean (Min. 126), and a memorial replica was sold at Sotheby's, 28 March 1977, lot 171.

Ivory: oval, 91 × 75 mm, signed and dated, left: *Augustin 1814.*
Bentinck Hawkins Collection, 1894 [1897.149]. Min. 125

[1] Millar 1992, no. 308.
[2] *ibid.,* no.810.
[3] Williamson 1904, p. 76.
[4] Long 1929a, p. 255.

96 95 97

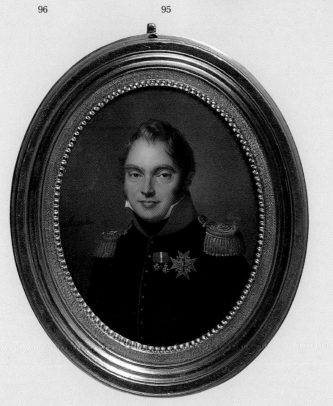

98

William Grimaldi (1751–1830)

99 Paolo Pasquale, 1800

Paolo Pasquale (1725–1807), Corsican general and patriot. He was a political refugee in England twice, the second time from 1795, when he was awarded a pension by the British government, probably being the occasion of Grimaldi's portrait.[1] Grimaldi (8th Marquess Grimaldi) was Miniature Painter to George IV.

Watercolour on card: oval, 85 × 71 mm, inscribed on the reverse: *Gen.Paoli Painted by W.Grimaldi 1800 Miniature painter to their R.H. the Duke & Duchess of York. HBG* [erased] *sold to LBG.* De la Hey Bequest, 1936 [1936.156]. Min. 227

100 The Duke of Wellington, *c.*1817

Arthur Wellesley, 1st Duke of Wellington (1769–1852), Field Marshal and Prime Minister. Grimaldi made several profiles of the Duke, in the form of a marble cameo trompe l'oeil. The original is not certain, but may have been an early strike of Pistrucci's Waterloo Medal.[2]

Enamel on copper: octagon, 66 × 50 mm, inscribed in black paint on the counter-enamel: *F1111 Duke of Wellington Prince of Wales 108 By W.Grimaldi Enamel Painter to the Prince Regent.* Mounted on brown velvet.
Bentinck Hawkins Collection, 1894 [1897.109]. Min. 85

J. Parent (fl. 1815–33)

101 Napoleon, 1815

Napoleon Bonaparte (1769–1821), Emperor of France. No. 101 is a copy of a type of portrait Augustin probably made in *c.*1810, of which variants are in Windsor Castle and the Wallace Collection.[3] Napoleon wears the uniform of the Chasseurs-à-Cheval de la Garde and the watered red riband of the Legion of Honour.

Ivory: oval, 61 × 49 mm, signed and dated, neatly, right: *J Parent 1815.* Gold orobouros rim in rectangular gold frame engraved with bees, on the reverse the date *1815* below another orobouros enclosing the letter *N.*
Bentinck Hawkins Collection, 1894 [1897.153]. Min. 129

[1] Grimaldi's catalogue lists two versions of 1800 and an outline drawing.
[2] A version in the Royal Collection is described in Walker 1992, no. 824.
[3] Reynolds 1980, nos. 169–70 and Walker 1992, no. 26.

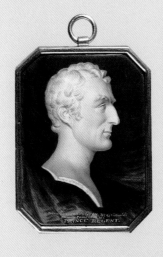

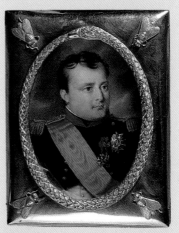

100 101

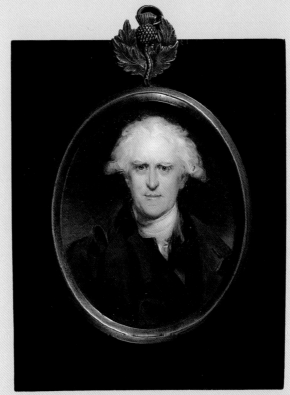

99

Glossary

Body colour: opaque water-soluble paint achieved with a binder such as gum arabic, or by the addition of gouache or white pigment.

Card: playing card, burnished, stuck to vellum and used as a support.

Carnation: transparent watercolour over a coloured (usually pink) ground.

Counter-enamel: the reverse side of an enamel plaque.

Enamel: brass or gold plate, primed, painted with a vitreous glaze, and fired several times. The technique was brought to Europe from China, became popular in France and Switzerland, and arrived in England via Petitot and Boit. Zincke was a prolific enamel miniaturist but the method declined during the eighteenth century until it was revived by Henry Bone and his family.

Glair: medium made from white of eggs and used to bind pigments, mainly for illumination.

Gouache: watercolour paint rendered more opaque by white pigment, exploited with great effect by Samuel Cooper.

Gum arabic: similar to Glair but made from acacia sap and used in watercolour to increase gloss.

Hatching: parallel strokes used instead of stipple for modelling the contours. Exploited with great skill to achieve a three-dimensional effect, especially by Meyer and Cosway.

Impress (impresa): a portrait containing a pictorial device, usually accompanied by a motto and full of hidden meaning.

Ivory: small sheets of ivory replaced mussel shells as palettes in the early 17th-century. As a support ivory replaced card or vellum. Slices of ivory are believed to have been first used in Venice by Rosalba and imported to England in about 1707.

Limn: to paint or draw, from the word 'illumination'.

Nacre enamel: an unusual vehicle of shell or mother-of-pearl, believed to achieve an iridescent effect after firing the enamel.

Orobouros: a symbol of eternity, usually a circle formed by a serpent biting its tail.

Parchment: sheep or goatskin prepared as paper and used in Flemish illumination.

Recto: the right hand page, and also the upper side of a folio or miniature.

Spud: a hoe-like tool used for weeding or guiding sheep, and a favourite device in Van Dyck and Lely portraits of ladies posing as shepherdesses.

Sfumato: literally evaporated: a softening or smoky effect specially favoured by Peter Cross who used a dotted stipple to achieve sfumato.

Stipple: modelling with fine dots of grey or coloured pigment, sometimes rather mechanical but used with great effect by Smart and Humphry.

Vellum: a fine parchment usually pasted to playing cards and described as 'tablets'.

Verso: the left hand page, and also the reverse side of a folio or miniature.

Watercolour: a transparent water-soluble paint usually applied to a white surface (paper or ivory) in order to obtain reflection.
Watered: a wavy lustrous pattern, especially on the broad ribands of an Order of Chivalry.

The technique of miniature painting is brilliantly described by Jim Murrell in chapter one of *The English Miniature* (1981) by Murdoch, Murrell, Noon and Strong.

Bibliography

Auerbach 1961. Erna Auerbach, *Nicholas Hilliard,* London.

Bayne-Powell 1995. Robert Bayne-Powell, *Catalogue of Miniatures in the Holburne Museum and Bath Crafts Centre, Bath,* Bath.

Bayne-Powell 1985. Robert Bayne-Powell, *Catalogue of Portrait Miniatures in the Fitzwilliam Museum, Cambridge,* Cambridge.

BFAC 1899. Burlington Fine Arts Club, 'Exhibition of Miniatures'.

Blättel 1992. Harry Blättel, *International Dictionary Miniature Painters Porcelain Painters Silhouettists,* Munich.

Brown 1982. D.B.Brown, *Ashmolean Museum Oxford: Catalogue of the Collection of Drawings, Vol IV, The Earlier British Drawings,* Oxford.

Arts Council 1965. 'The British Portrait Exhibition', Edinburgh.

Edmond 1979. Mary Edmond, 'Peter Cross, Limner', *Burlington Magazine,* CXXI , pp. 585–6.

Edmond 1983. Mary Edmond, *Hilliard and Oliver,* London.

Edmond 1978–80. 'Limners and Picturemakers', *Walpole Society,* XLVII , pp. 60–242.

Finsten 1981. Jill Finsten, *Isaac Oliver,* New York.

Foskett 1964. Daphne Foskett, *John Smart: The Man and his Miniatures,* London.

Foskett 1965. Daphne Foskett, 'John Hoskins – Miniaturist', *Antique Collector.*

Foskett 1974. Daphne Foskett, *Samuel Cooper 1609–1672,* London, see also NPG 1974.

Foskett 1987. Daphne Foskett, *Miniatures, Dictionary and Guide,* Woodbridge.

Foster 1898. Joshua James Foster, *British Miniature Painters and their Works,* London.

Foster 1903. Joshua James Foster, *Miniature Painters, British and Foreign,* London.

Foster 1926. Joshua James Foster, *Dictionary of Painters and Miniatures,* London.

Goulding 1916. R.W.Goulding, 'The Welbeck Abbey Miniatures', *Walpole Soc.,* IV.

Kerslake 1977. John Kerslake, *Early Georgian Portraits,* London.

Lloyd 1995. Stephen Lloyd, *Richard and Maria Cosway: Regency Artists of Taste and Fashion,* Edinburgh.

Long 1929a. Basil Long, *British Miniaturists,* London.

Long 1929b. Basil Long, 'Richard Crosse, Miniature and Portrait Painter', *Walpole Soc.,* XVII.

Long 1930. Basil Long, *Handlist of Miniature Portraits in the Victoria and Albert Museum,* London.

Millar 1963. Oliver Millar, *The Tudor, Stuart, and Early Georgian Pictures in the Collection of Her Majesty the Queen,* 2 vols, London.

Millar 1969. Oliver Millar, *The Later Georgian Pictures in the Collection of Her Majesty the Queen,* 2 vols, London.

Millar 1992. Oliver Millar, *The Victorian Pictures in the Collection of Her Majesty the Queen,* 2 vols, Cambridge.

Murdoch 1978. John Murdoch, 'Hoskins and Crosses: Work in Progress', *Burlington Magazine,* CXX, pp. 284–90.

74

Murdoch 1981. John Murdoch, Jim Murrell, Patrick Noon & Roy Strong, *The English Miniature,* New Haven & London.
Murdoch. John Murdoch, *Catalogue of Miniatures in the Victoria & Albert Museum* (forthcoming).
Murdoch & Murrell 1981. John Murdoch and V.J.Murrell, 'The Monogrammist D G: Dwarf Gibson and his Patrons', *Burlington Magazine,* CXXIII , pp. 282–9.
NPG 1974. National Portrait Gallery, *Samuel Cooper and his Contemporaries* (catalogue by Daphne Foskett).
Oppé 1950. A.P.Oppé, *English Drawings from the Collection of His Majesty the King at Windsor Castle,* London.
Ormond 1973. Richard Ormond, *Early Victorian Portraits,* London.
Piper 1963. David Piper, *Seventeenth Century Portraits,* London.
Piper 1977. David Piper, *The Treasures of Oxford,* London.
Piper 1978 (new edn ed. Malcolm Rogers 1992). David Piper, *The English Face,* London.
Poole 1912–25. Mrs Reginald Lane Poole, *Catalogue of Portraits in the Possession of the University, Colleges, City and County of Oxford,* 3 vols, Oxford.
RA 1956–57. Royal Academy winter exhibition, *British Portraits.*
RA 1960–61. RA winter exhibition, *The Age of Charles II.*
Reynolds 1947. Graham Reynolds, 'A Miniature Self-Portrait by Thomas Flatman', *Burlington Magazine,* LXXXIX , pp. 63–7.
Reynolds 1947. Graham Reynolds, *Nicholas Hilliard & Isaac Oliver* London.
Reynolds 1952 (new edn 1988). Graham Reynolds, *English Portrait Miniatures,* Cambridge.
Reynolds 1980. Graham Reynolds, *Wallace Collection: Catalogue of Miniatures,* London.
Reynolds. Graham Reynolds, *Tudor and Stuart Miniatures in the Collection of Her Majesty the Queen* (forthcoming).
Rosenberg 1996. Pierre Rosenberg, 'De qui sont les miniatures de Fragonard?', *Revue de l'art,* 111, pp. 66–76.
Schaffers-Bodenhausen 1993. Karen Schaffers-Bodenhausen & Marieka Tiethoff-Spliethoff, *The Portrait Miniatures in the Collection of the House of Orange-Nassau,* Zwolle.
Schidlof 1964–5. L.R.Schidlof, *The Miniature in Europe,* Graz.
SKM 1862. South Kensington Museum, *Special Exhibition of Works of Art.*
SKM 1865. South Kensington Museum, *Special Exhibition of Portrait Miniatures.*
Strong 1969. Roy Strong, *Tudor and Jacobean Portraits,* London.
Strong 1984. Roy Strong, *The English Renaissance Miniature,* London.
Tradescant's Rarities 1983. *Tradescant's Rarities: Essays on the Foundation of the Ashmolean Museum,* ed. Arthur Macgregor, Oxford.
Tudor Court 1983. Roy Strong & Jim Murrell, *Artists of the Tudor Court,* London.
V & A 1929. Victoria & Albert Museum, *Special Exhibition of Portrait Miniatures.*
V & A 1981. *Summary Catalogue of Miniatures in the Victoria and Albert Museum.*
Walker 1985. Richard Walker, *Regency Portraits,* London.
Walker 1992. Richard Walker, *The Eighteenth and Early Nineteenth Century Miniatures in the Collection of Her Majesty the Queen* Cambridge.
Williamson 1920. G.C.Williamson, 'The Bentinck Hawkins Collection of Enamels at the Ashmolean Museum, Oxford', *Connoisseur,* LVI , pp. 34–7.
Williamson & Engleheart 1902. G.C.Williamson and Henry Engleheart, *George Engleheart 1750–1829: Miniature Painter to George III,* London.